ROYAL ACADEMY ILLUSTRATED 2009

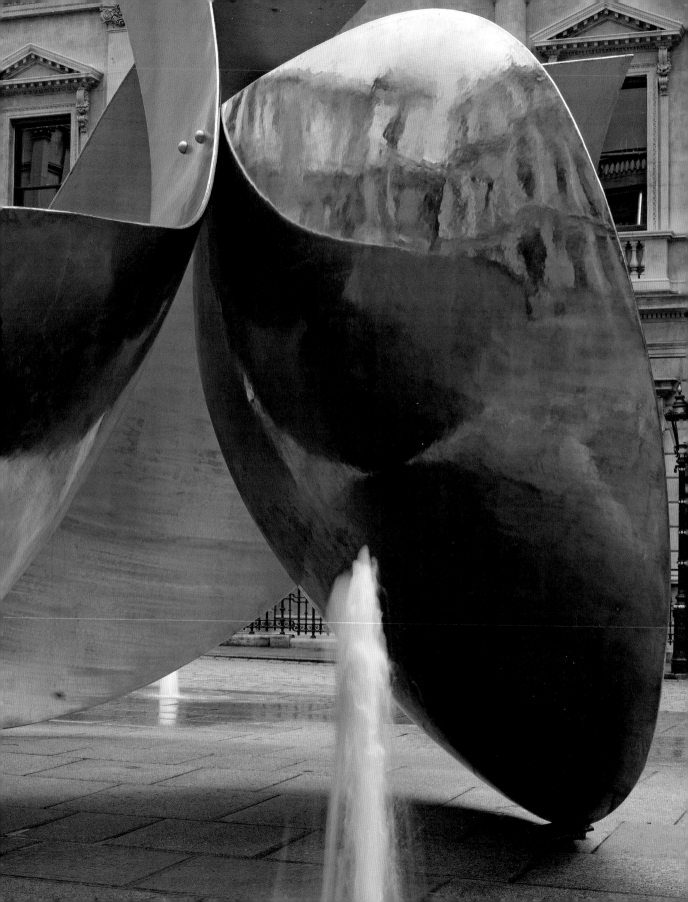

A selection from the 241st
Summer Exhibition

Edited by Eileen Cooper RA

ROYAL ACADEMY ILLUSTRATED 2009

SPONSORED BY

ROYAL ACADEMY OF ARTS

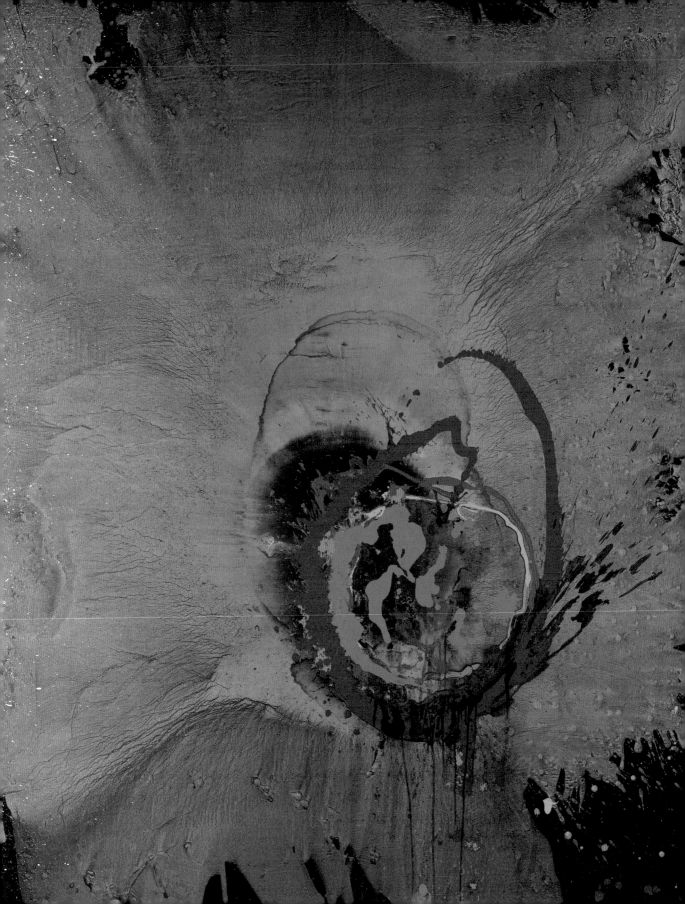

Contents

Sponsor's Foreword

Insight Investment is delighted, as lead sponsor, to continue its association with the Royal Academy of Arts and the artistic talent for which the Summer Exhibition is widely renowned.

Insight is a specialist asset manager at the forefront of building investment solutions designed specifically to meet its clients' evolving needs. Launched in 2002, we have grown to become one of the largest asset managers in the UK, winning industry recognition for our investment capabilities. Our investment platform has been built to give complete flexibility across a broad range of asset classes, an essential tool in providing tailored client solutions. With well-resourced, highly skilled teams, we aim to achieve consistent and repeatable returns. We cover the entire risk/return spectrum, offering our clients absolute or relative return performance benchmarks.

Our ongoing partnership with the Royal Academy is driven by two shared values: innovation and creative thinking. Innovation is key to the development of our investment capabilities and as leaders in our particular areas of expertise we continue to look for opportunities to expand our business to reach new clients and countries. For us, creative thinking is about breaking ground, challenging convention and thinking boldly and differently in everything we do, qualities that are in abundance at this year's Summer Exhibition.

This is now our fourth year of sponsorship and we very much hope that visitors to the exhibition, along with our clients, business partners and colleagues, will find new sources of inspiration in the works on display.

More insight. Not more of the same.

Abdallah Nauphal
Managing Director

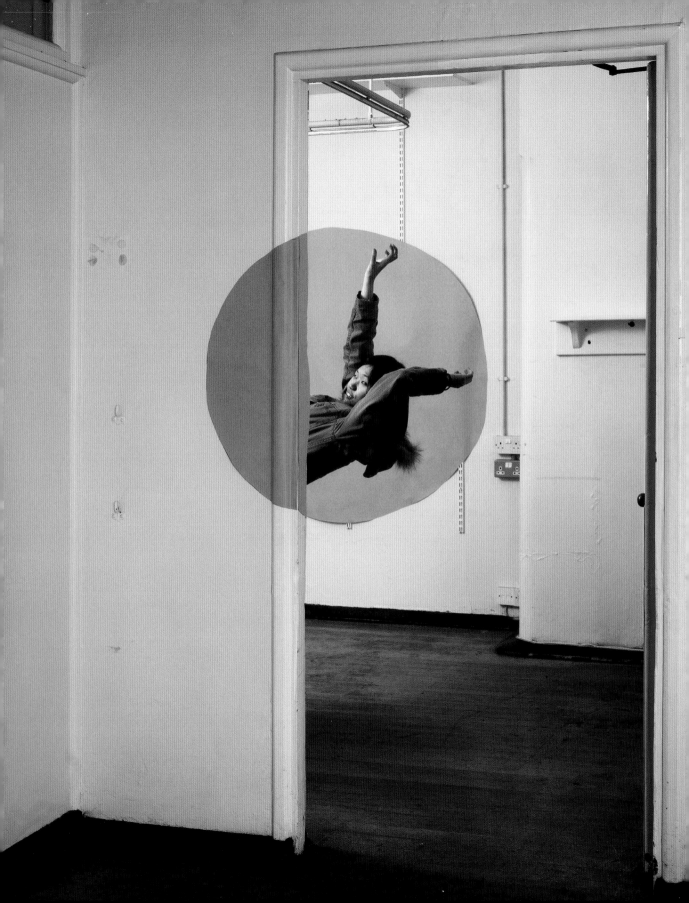

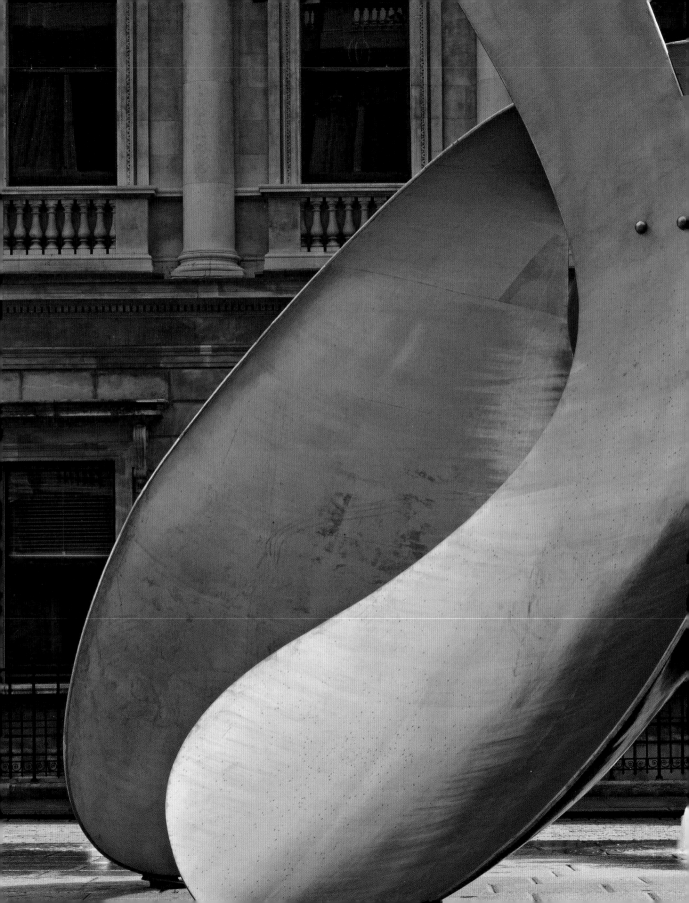

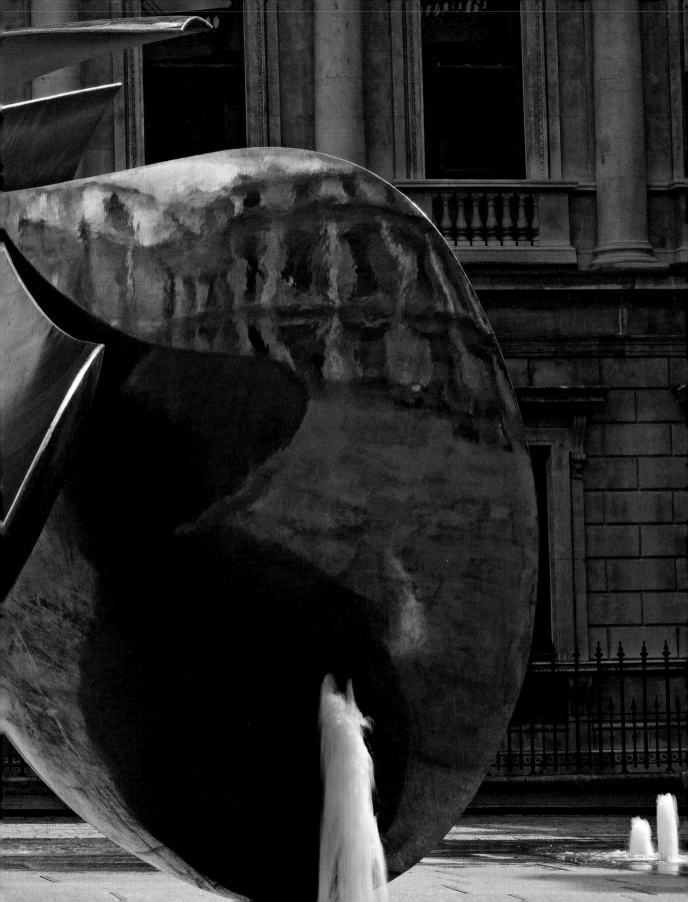

Introduction
Richard Cork

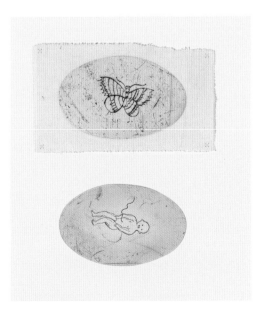

Louise Bourgeois
Baby and Butterfly
Drypoint and engraving
36 × 30 cm

Damien Hirst
St Bartholomew, Exquisite Pain
Silver
H 250 cm

'Making space': behind those two words, the theme of the Royal Academy's 241st Summer Exhibition, lies a desire to embrace as many different art forms as possible. In the past, critics have denounced the show for its refusal to admit some of the more adventurous new initiatives in contemporary art practice. But now, as the first decade of the twenty-first century prepares to reach its end, the Academy has become a far more open-minded institution. Rather than excluding audacious and inventive approaches, it wants to find room for them.

Ann Christopher, one of the three co-ordinators of this year's exhibition, came up with its liberating theme. As a sculptor, she is particularly eager to 'shake up' the galleries with three-dimensional work displayed on the walls. But the 'making space' theme also signifies her willingness to 'hang figurative art with non-figurative, elders with youngers', and to diversify the media shown: 'We decided to include much more photography than usual – a lot of photographic work was submitted this year, including digital art. In my view, if you want to produce an image, it doesn't matter how you do it.'

The other co-ordinators are equally determined to break down territorial boundaries. Eileen Cooper, who is exhibiting her own vigorous woodcuts of bathing figures as well as some of her screenprints and paintings, has focused on 'mixing different kinds of work much more than we normally do'. Standing in the Large Weston Room, which has traditionally been regarded as a haven for prints, she gestures towards a flamboyant sculpture by Allen Jones curving across the floor. 'We don't want ghettos any more,' Cooper insists, before explaining, 'I'm after surprising juxtapositions. Elsewhere in the show photographs are mixed with paintings, and here we move from wood engravings to digital works on the same wall. I love the hybrid character of this room: you find tasteful monochrome images hanging near loud, vibrant works.'

Will Alsop, the third co-ordinator, shares this urge to bring together disparate elements. He might have been expected to concentrate on the exhibits submitted by his fellow architects. But he points out that the co-ordinators have 'worked far more closely than architects and artists have done in previous years,' approving of the way 'the Summer Exhibition brings those practitioners together, which is invaluable and doesn't happen anywhere else'. Alsop is an enthusiastic painter himself, and one of his canvases – a splashy, luminous and energetic work called *I Wish My Garden Was Really Like This* – enlivens Gallery V this year. 'I do a hell of a lot of painting,' he says, claiming that 'art and architecture have become much closer and I welcome that. As part of an architectural project, I can make a huge painting. It forces you to go on a journey while the paint dries.'

In order to further this dialogue Alsop has included work by sculptors in the Architecture Room, and encouraged architects to 'send in only three-dimensional work, preferably sketch models,

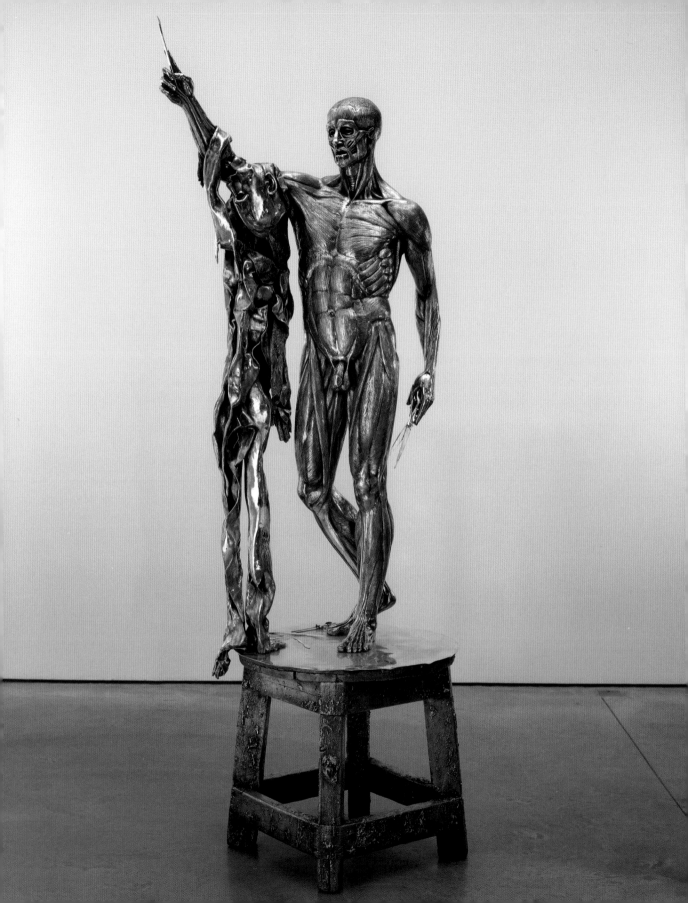

which the public love looking at. Architects' drawings are much more difficult for visitors to enjoy.' For that reason, rows of shelves have been specially installed in the room this year. As Alsop explains, 'I have also painted the whole room black so that you can see the models more clearly. I used to have a completely black studio myself, but in the end I made it white because I got quite depressed!'

Impelled by a similar urge to experiment with presentation, Ann Christopher has installed a number of sculptural works on the walls of Gallery IV. The result is immensely stimulating. Antony Gormley's dynamic exhibit is a figure, and yet it explodes outwards in a burst of thrusting diagonal rods. 'Gormley responded to the "making space" theme with a sculpture that comes right out into the room,' says Christopher, who then points up at Allen Jones's floating dancer suspended above our heads. Wherever you look in this gallery, sculpture has been allowed to assert itself with invigorating freedom. One of Bill Woodrow's works invades our space with branch-like forms that impale a book and make its open pages bleed. David Nash's vertical wall-piece seems to have been sliced from top to bottom. And violence also erupts in Christopher's own powerful sculpture, from which a spiky form suddenly shoots down and casts a dramatic shadow across a white board.

Sculpture, in fact, announces the exhibition even before visitors enter the galleries. As soon as we escape from traffic-ridden Piccadilly and enter the courtyard of Burlington House, Bryan Kneale's spectacular stainless-steel *Triton III* declares its monumental presence. The title suggests that Kneale may have taken as his starting point the Greek sea-god, usually represented as a man with a fish's tail, carrying a trident and a shell-trumpet. But by the time Kneale finished simplifying and distorting the sculpture's three components, they asserted themselves in a more abstract way, as convex and concave forms, some polished enough to catch us off-balance with surprising reflections of the courtyard itself.

Nor is there a break when we move into the Central Hall of the Summer Exhibition galleries. Our eyes are arrested at once by Damien Hirst's gleaming silver figure, a commanding statue of St Bartholomew. With the skin stripped from his body, the full complexity of his muscular structure is exposed. And the saint reinforces this surgical aura by clasping in his purposeful hands a scalpel and a gigantic pair of scissors, ready to cut.

The co-ordinators of the exhibition have given the work of several major Honorary Academicians generous space in Gallery I. Anselm Kiefer's massive triptych contains a haunting assemblage of real branches and ruined structures, tumbling down and jutting out like sculptures. These elements seem uncannily in the spirit of the 'making space' theme, and Kiefer places them in an epic context, a forest scene painted in thick, cracked impasto. The ominous mood of Kiefer's work could not be further removed from the

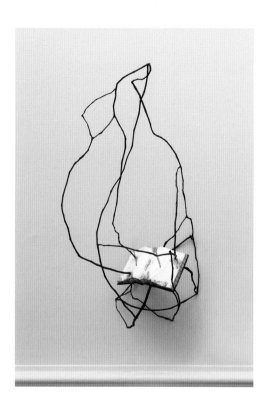

Bill Woodrow RA
Centrefold
Bronze
H 87 cm

Allen Jones RA
High Wire
Painted aluminium
264 × 152 cm

whirling geometry of the two wall reliefs by Frank Stella that flank it. And on the opposite wall Ed Ruscha ambushes us with another surprise: a painting of snow-covered mountains called, almost alarmingly, *Blazing Orifices*. Is Ruscha predicting an imminent global meltdown? He offers no explanation, but Michael Craig-Martin's mesmeric painting above spells out the corrosive word 'envy'.

The biggest of the contributions from Honorary Academicians has a similarly complex, disturbing impact. Most of Cy Twombly's vast painting in Gallery III is occupied by three gigantic roses, bursting like bombs and sending multiple streams of pigment coursing down to the base of the board. Inscribed next to them in Twombly's typically wavering script, an impassioned poem by Rainer Maria Rilke refers to flowers 'wet as one who weeps'. Yet melancholy is offset by Rilke's reassuring description of the flowers as they 'lean against the dawn'. And this incipient sense of hope is reinforced by Louise Bourgeois's contribution to the Large Weston Room, a drypoint and engraving that shows a baby and a butterfly enjoying a state of amiable – albeit vulnerable – co-existence.

Throughout the Summer Exhibition, the inevitability of mortal loss is offset by delight. The death of Jean Cooke, a regular contributor to the show since 1965, is marked by a memorial display of her paintings in the Central Hall. Elsewhere, though, the election of new Academicians Spencer de Grey, Michael Landy and Tacita Dean is a cause for celebration. De Grey has enjoyed a highly distinguished architectural career since joining Foster Associates in 1973, while Landy shows penetrating studies of plants and faces in the Large Weston Room, as well as works in Gallery III. And in Gallery IV we can savour Dean's potent *Small Study for Monkey Puzzle II*, a gouache painted on a fibre-based photograph.

As Dean's work proves, no arbitrary limits should be placed on the media artists can now deploy. Gallery IX is devoted entirely to photographic work of many different kinds, while next door in Gallery X a dramatic showcase of film work selected by the ebullient Richard Wilson is being screened. Wilson sees his big, tilting projection screen as 'a wall that appears to have been ripped from another interior space'. Declaring that he wants this unconventional set-up to 'seize the onlooker', Wilson explains that 'like the films projected, the room aims to magnify the abandonment of customary approaches and through this unexpected encounter capture us by surprise'. It is an historic moment, too: the Royal Academy has never before devoted a whole room of the Summer Exhibition to film. Wilson's selection, comprising nineteen works, ranges from senior practitioners like William Raban to young, promising artists like Matt Calderwood. Projected by a cone of light, the films bear out Wilson's belief that the medium has become 'an unavoidable artistic practice of the twenty-first century, giving greater diversity to art forms. It deserves to be celebrated, so this room is saying, "it's here, and in a big way".'

Tribute to
Jean Cooke RA
(1927–2008)

In her youth, Jean Cooke focused her tireless energy on sculpture rather than painting. Studying at the Central School of Arts and Crafts under Bernard Meninsky before moving on to Goldsmiths College, she became increasingly fascinated by the possibilities of working with ceramics and modelling in clay. The daughter of a grocer, she had modelled heads in plasticine even as a child. But after injuring her thumb in a cycling accident, Cooke ran a pottery studio near the family home in East Dean, Sussex.

Meeting the flamboyant John Bratby changed everything. After a swift and dramatic courtship, Cooke married him in 1953. He persuaded her to turn to brushes, colour and canvas, and she won a postgraduate place at the Royal College of Art to study painting, where she was stimulated by the teaching of Ruskin Spear and Carel Weight. At that time, women artists rarely won prominence in the patriarchal world of British art, yet Cooke's work was purchased by the eminent collector Sir Brinsley Ford. While bringing up four children, she painted prolifically and with intensity. Like Bratby, she was committed to realism, but landscapes and still-life subjects claimed far more of her attention than portraits.

After receiving solo exhibitions in London at the Establishment Club and the Leicester Galleries, Cooke regularly showed in the Royal Academy's Summer Exhibition. She became an Associate of the Academy in 1965 and a full member in 1972. By then, her marriage was deteriorating, and she divorced Bratby five years later. But this small, indomitable woman continued to work with immense resilience. She adopted an increasingly free approach, painting outdoors in her ever wilder garden in London's Blackheath. She also returned incessantly to the Sussex countryside near Birling Gap, developing a pared-down style that gave her work its fundamental sense of direct engagement with the thing seen.

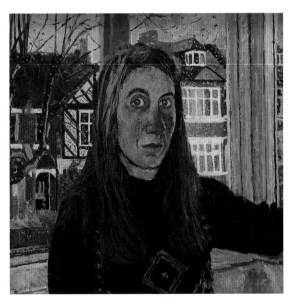

The late Jean Cooke RA
Jamais je ne pleure et jamais je ne ris
Oil
61 × 62 cm

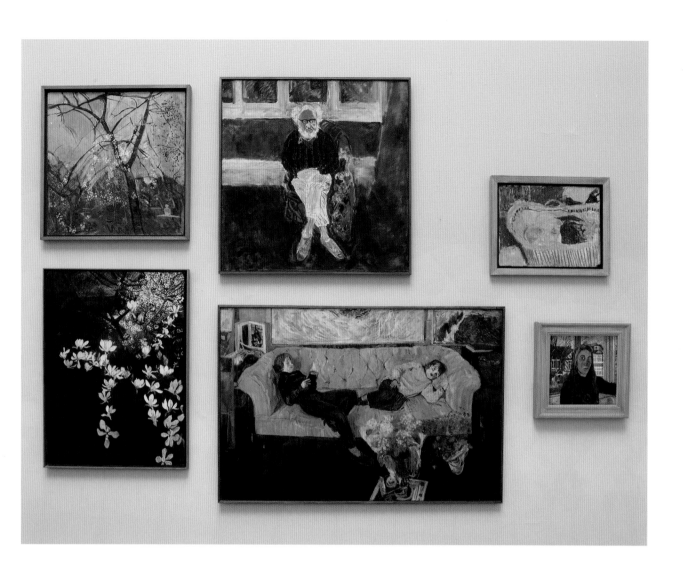

Paintings by the late Jean Cooke RA
in the Wohl Central Hall

Edward Burtynsky
Silver Lake Operations # 13, Lake Lefroy, Western Australia
Chromogenic colour print
120 × 150 cm

Prof John Hoyland RA
Winter Tiger
Acrylic
236 × 254 cm

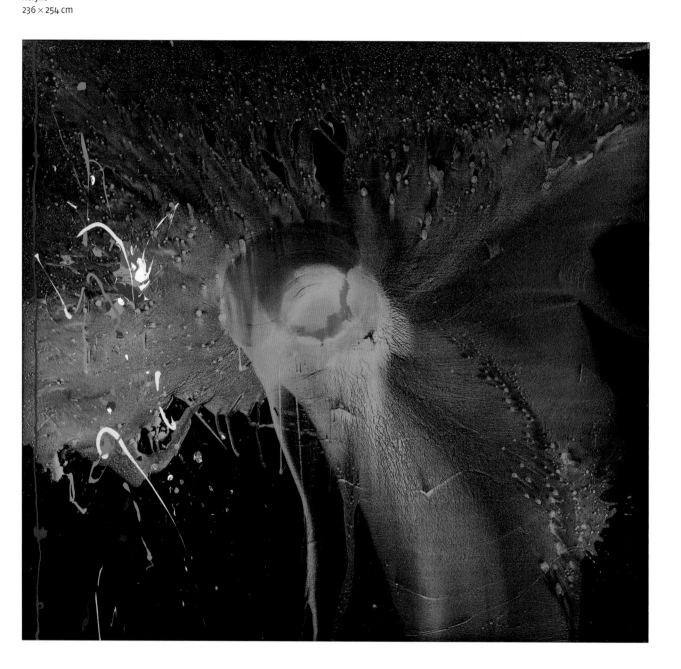

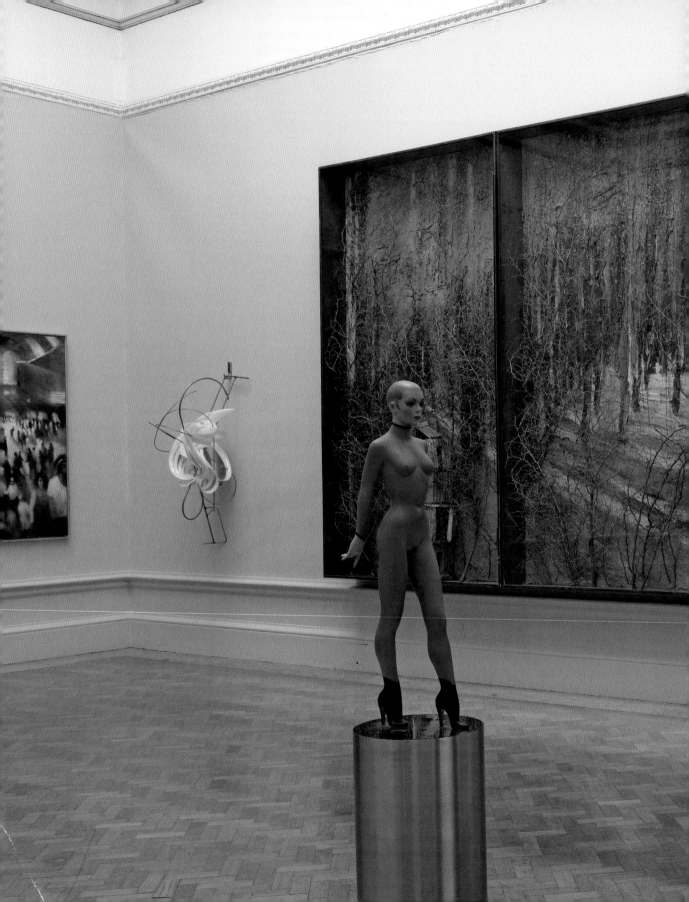

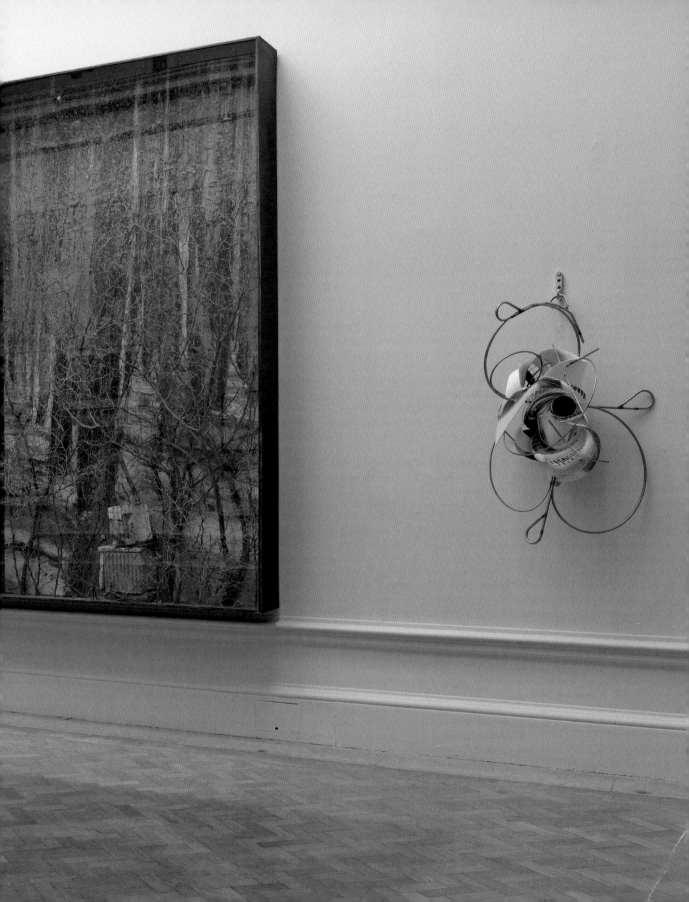

Mimmo Paladino Hon RA
Les Metamorphoses du Jour 3
Woodcut
57 × 41 cm

John Wragg RA
Incident
Acrylic
64 × 48 cm

Frank Stella Hon RA
K.37 lattice variation protogen RPT (mid-size), 2008
Mixed media
H 142 cm

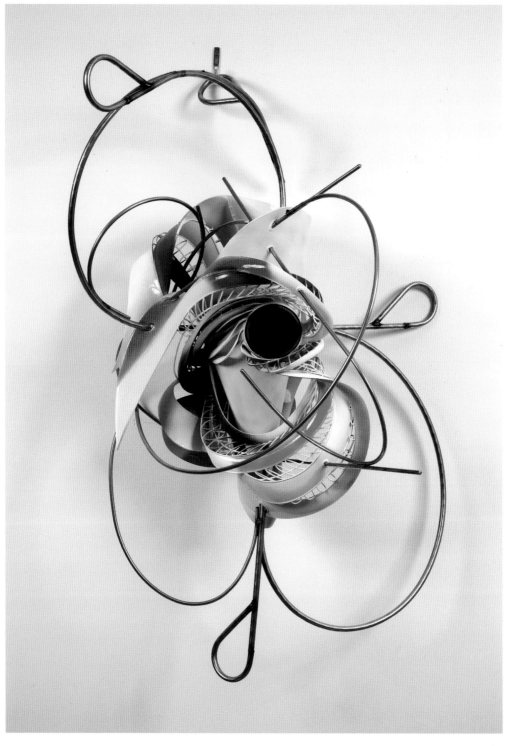

Antoni Tàpies Hon RA
Aixeta/Tap
Mixed media
130 × 162 cm

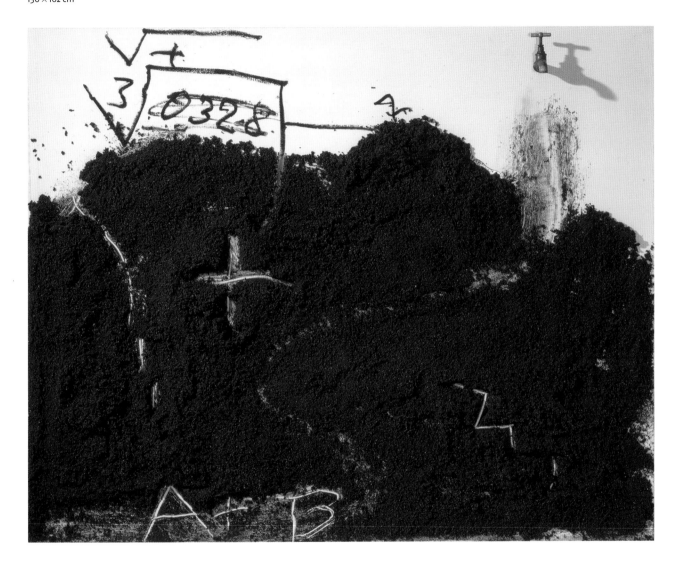

Georg Baselitz Hon RA
Lenin im Lehnstuhl (Lenin in the Easy-chair)
Oil
250 × 200 cm

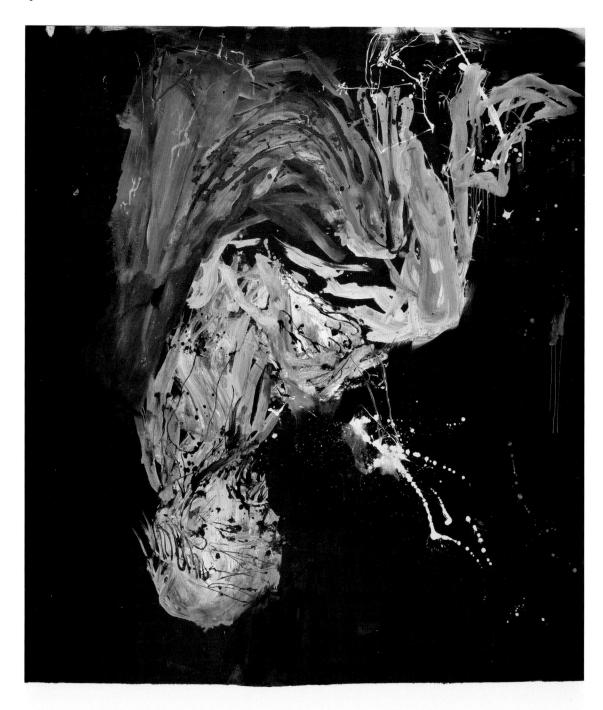

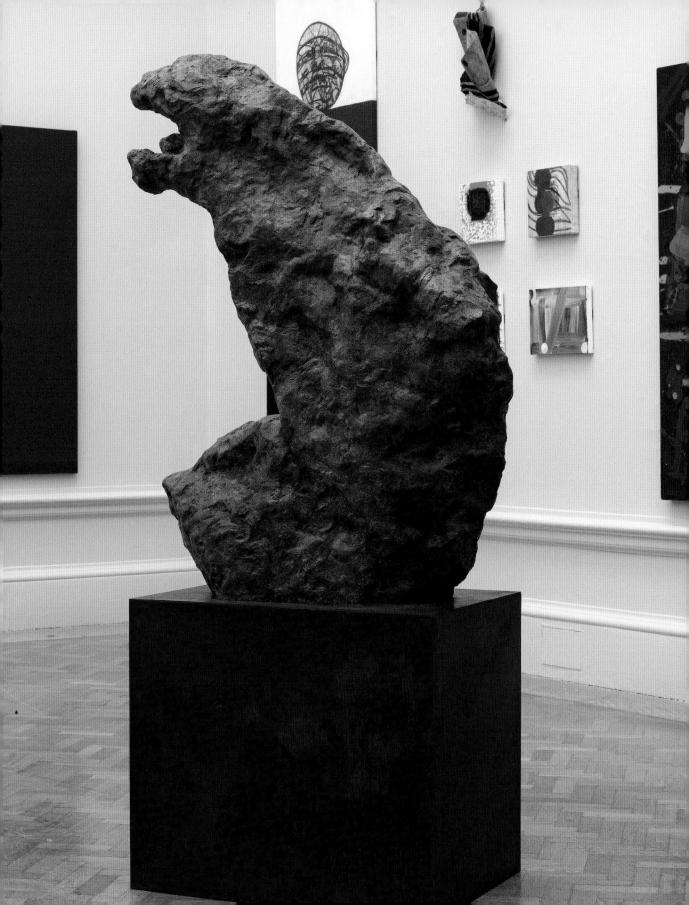

Tom Phillips CBE RA
Wittgenstein's Dilemma II
Steel
H 90 cm

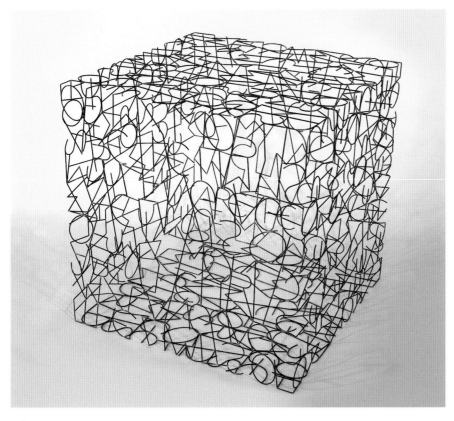

Tony Bevan RA
Tower
Acrylic and charcoal
190 × 163 cm

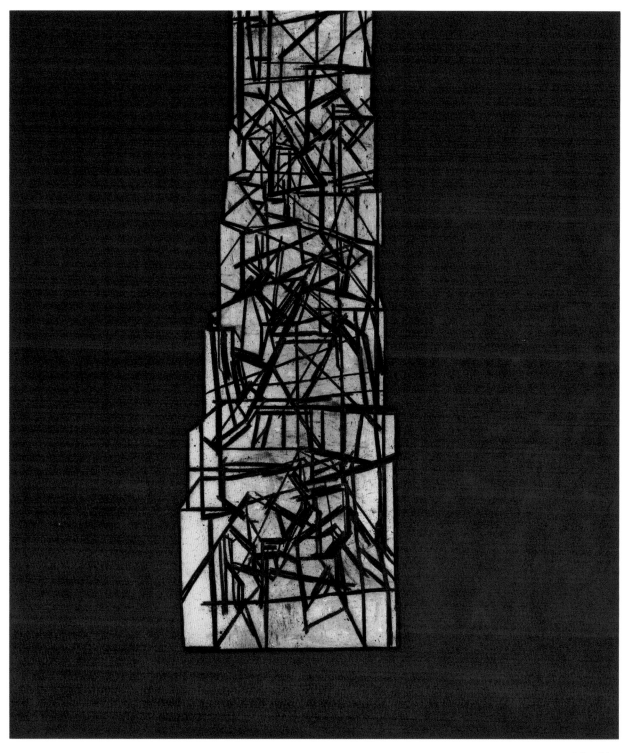

Mali Morris
Uncovered
Acrylic
30 × 40 cm

Philippa Stjernsward
After the Rain
Oil and wash
29 × 29 cm

Nigel Hall RA
Drawing 1487 (detail)
Gouache and charcoal
330 × 268 cm

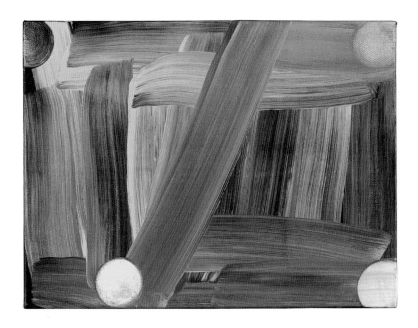

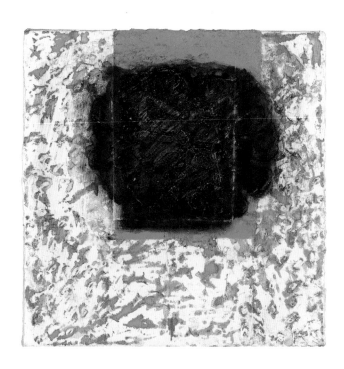

Basil Beattie RA
No Known Way (Janus Series)
Oil and wax
213 × 198 cm

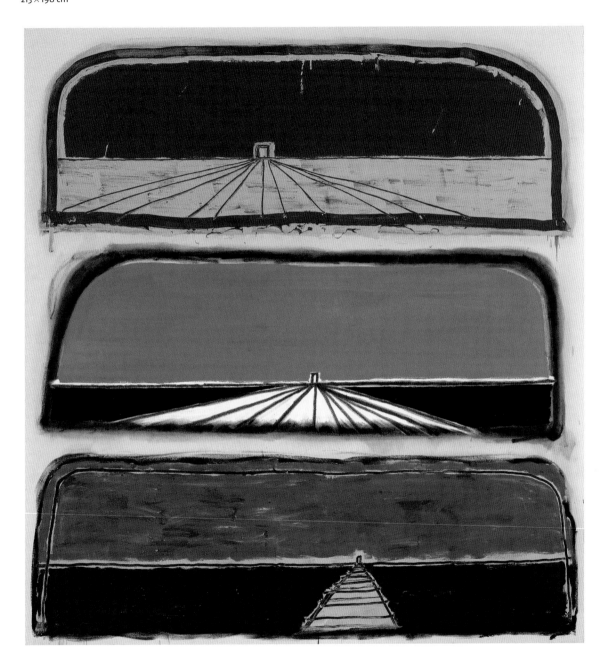

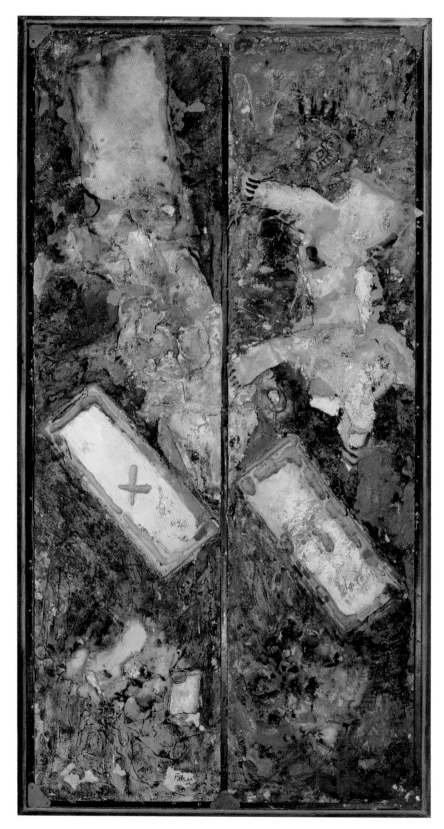

Terry Setch
Polar Melt
Mixed media
244 × 122 cm

Tess Jaray
After Damascus (detail)
Mixed media
75 × 88 cm

Prof Paul Huxley RA
Mutatis Mutandis XIV
Acrylic
137 × 137 cm

LARGE
WESTON
ROOM

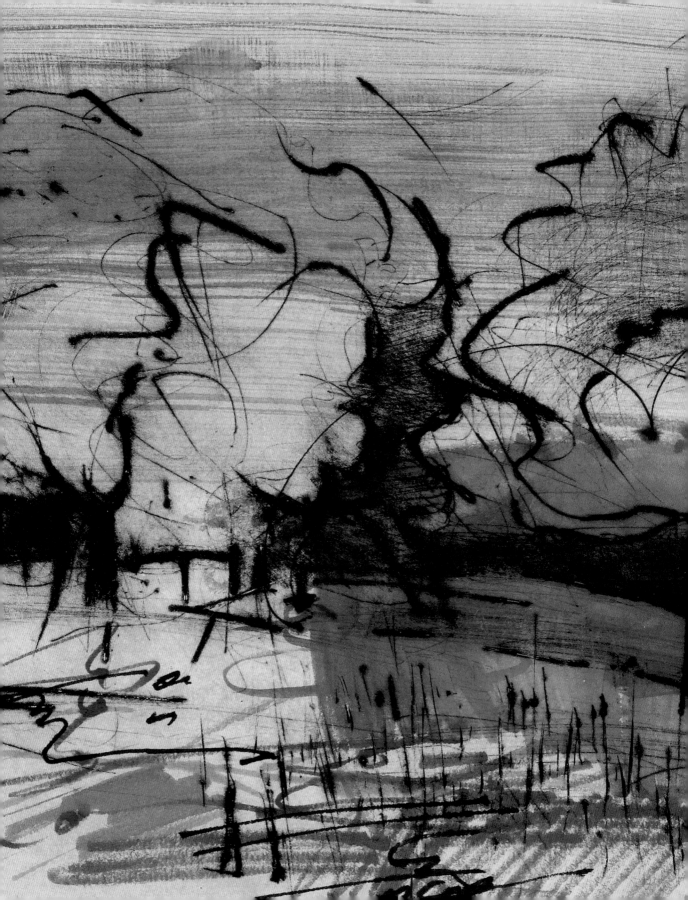

Peter Freeth RA
And He Marched Them All Down Again
Aquatint
30 × 29 cm

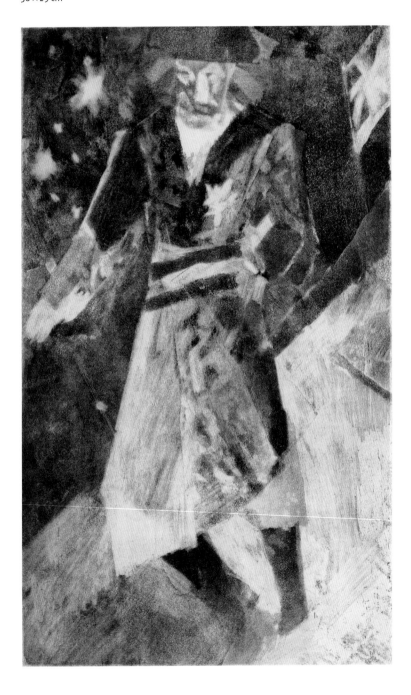

Stephen Walter
Swamp Hoodie
Screen– and inkjet print
75 × 73 cm

Francis Tinsley
Dark Baltic Trader
Woodcut and lithograph
45 × 61 cm

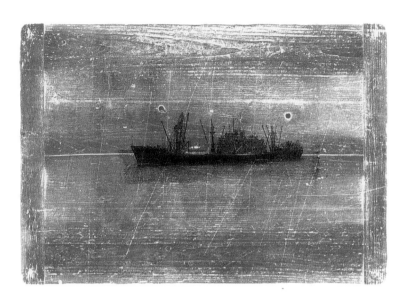

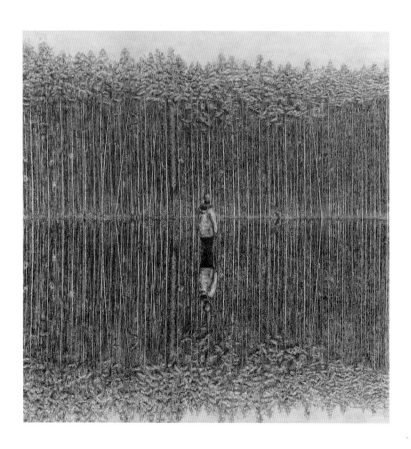

Vanessa Jackson
On Line II
Etching
50 × 40 cm

Richard Kirwan
Fool's Paradise
Digital print
53 × 63 cm

Oran O'Reilly
News Boy
Silkscreen and inkjet print
36 × 36 cm

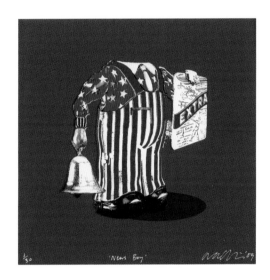

Keith Coventry
Junk II
Silkscreen
72 × 59 cm

Richard Wincer
Woodcutter's Wood
Woodcut
100 × 94 cm

Jason Oliver
Transmission
Mixed media
74 × 57 cm

Katsutoshi Yuasa
28
Woodcut
105 × 75 cm

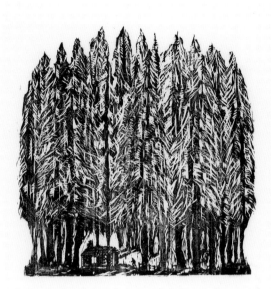

Prof Chris Orr MBE RA
Black Dog at Tower Bridge
Paper cut relief
55 × 78 cm

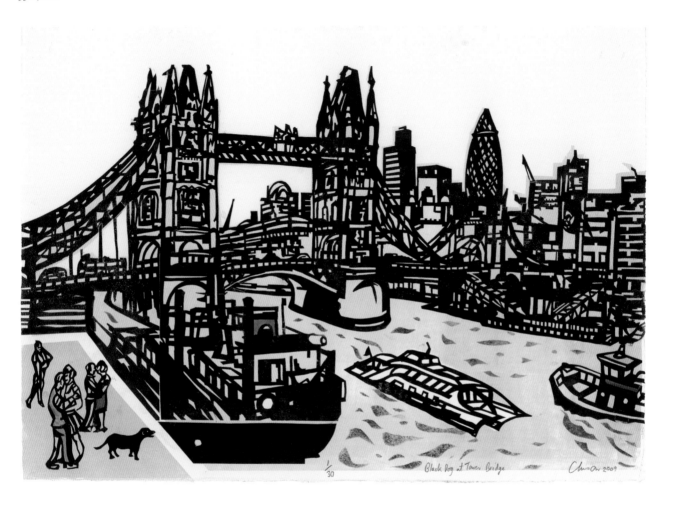

Rachel Champion
Information for Decision Making and Participation
Digital print
53 × 53 cm

Dick Jewell
Church and State
Inkjet print
59 × 56 cm

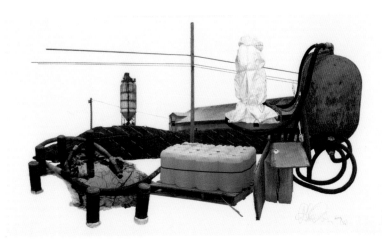

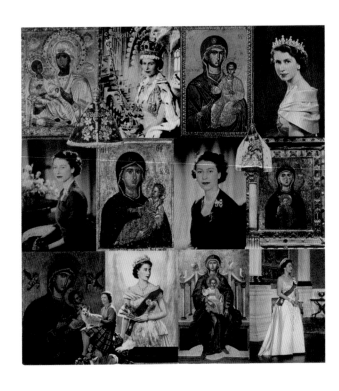

Jenny Wiener
The Old Woman Who Lived in a Shoe. Penelope, What Size is Your Shoe? (Scenes from the Odyssey)
Lithograph
74 × 51 cm

Colin Gale
Lozenge
Lithograph and monoprint
120 × 72 cm

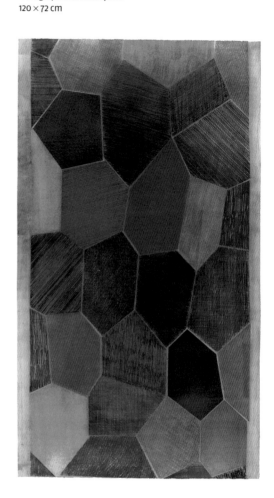

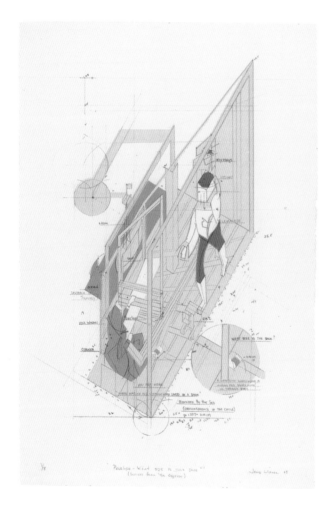

Bill Jacklin RA
Lake IV
Monotype
60 × 70 cm

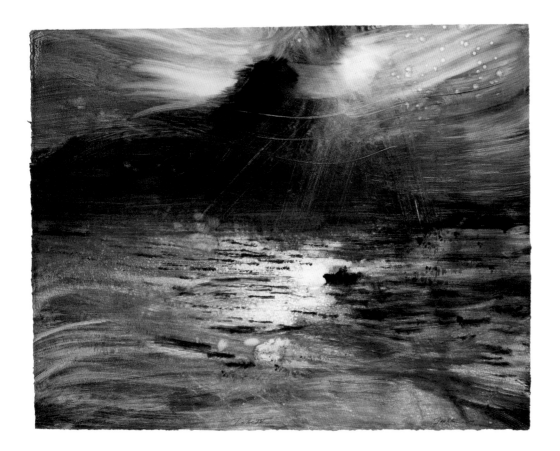

Prof Norman Ackroyd CBE RA
From Sutton Bank, Vale of York
Etching
48 × 78 cm

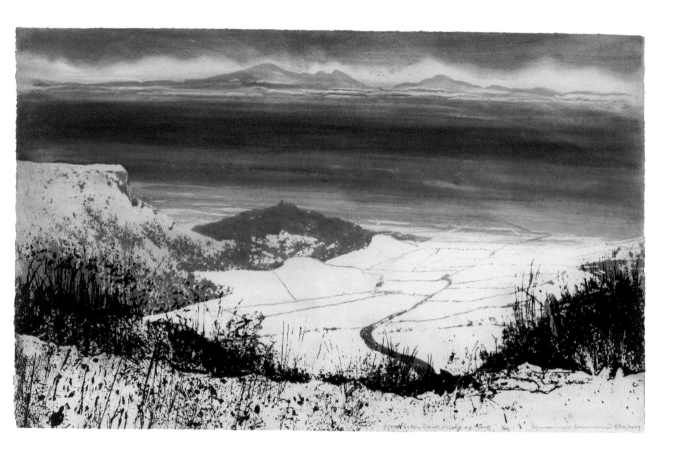

Lucy Farley
Hampstead Heath Summer
Drypoint and chine collé
40 × 43 cm

Gail Brodholt
Metroland
Linocut
53 × 53 cm

Dean Melbourne
The Longing
Linocut
56 × 41 cm

Simon Lawson
Ever Changing Skyline
Etching
34 × 68 cm

Mick Armson
Power Station, Greenwich
Linocut
43 × 38 cm

Frederic Morris
Hedonestate
Etching and aquatint
74 × 64 cm

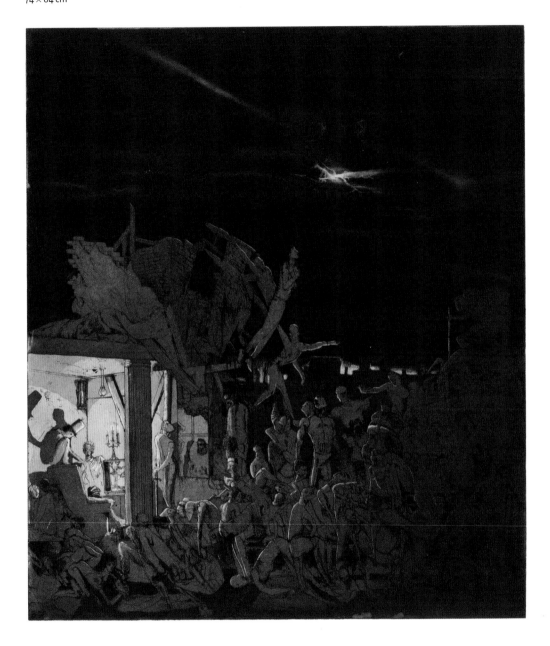

Moyna Flannigan
The Blind House 5
Etching
62 × 53 cm

Paula Rego
Guardians
Etching and aquatint
68 × 54 cm

Tony Carter
Sunflowers
Wood, bronze and copper
H 110 cm

Basia Lautman
Nubia
Etching
51 × 41 cm

Eileen Cooper RA
Little Darling
Woodcut
39 × 30 cm

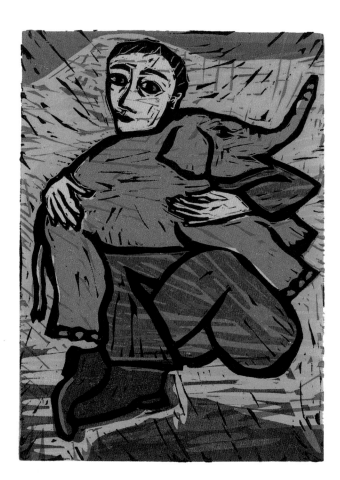

Edd Pearman
Bird Study, Panel 5
Screenprint
79 × 52 cm

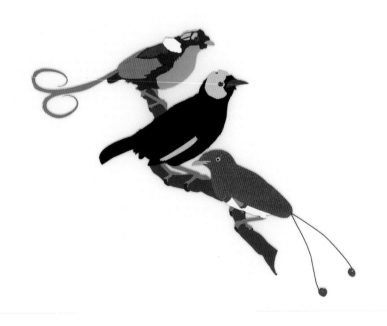

Helen Fay
Oscar
Etching
61 × 57 cm

John Hewitt
Spring Bull (Gallaber Borderway), off Ridge Lane, Diggle
Pencil
37 × 53 cm

Diana Howorth
Bumblebee
Aquatint and etching
10 × 10 cm

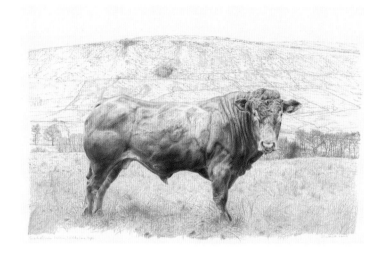

Joby Williamson
Stack
Relief print
90 × 30 cm

Ceal Warnants
A Fiddle
Digital print
H 61 cm

Claas Gutsche
10 pm
Lithograph
60 × 70 cm

Mila Judge–Fürstova
House I
Etching
60 × 58 cm

Christiane Baumgartner
Felder
Woodcut
77 × 97 cm

Jim Dine
Pruning
Mixed media
86 × 71 cm

Barton Hargreaves
Promised Land
Etching and digital print
62 × 80 cm

Sara Lee
Incoming
Etching and aquatint
47 × 60 cm

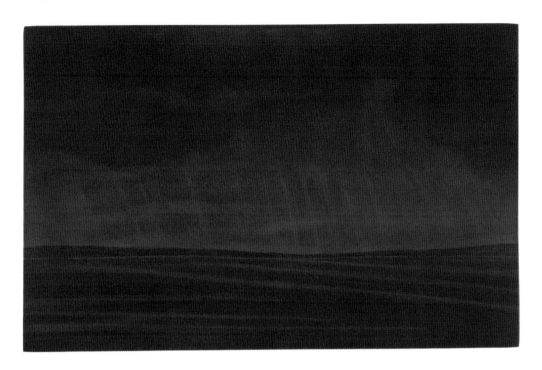

Dr Jennifer Dickson RA
Shimmering Light: Three (Palazzo Farnese, Caprarola)
Inkjet and watercolour print
62 × 75 cm

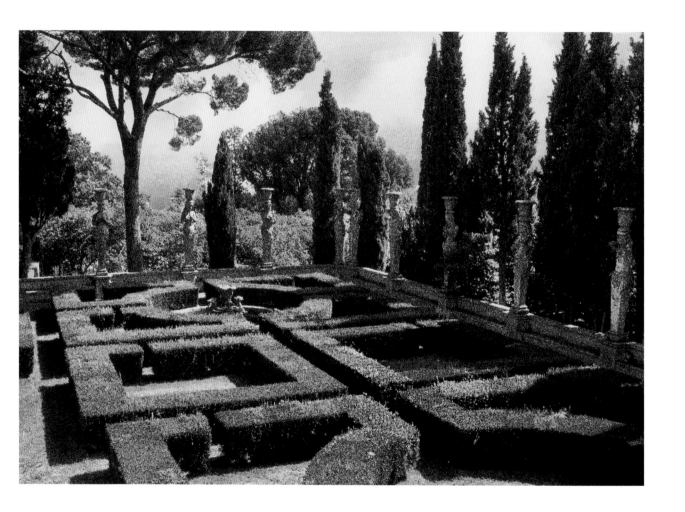

Anthony Green RA
Autumn Love 1 (Pink Lounge)
Etching and inkjet print
86 × 70 cm

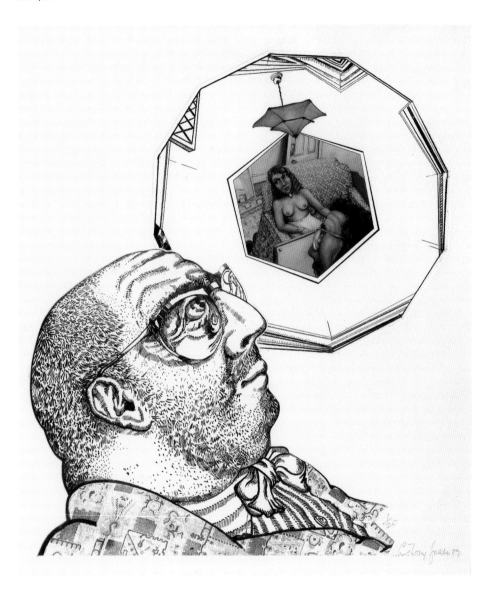

Flora Parrott
Lung Cross Section
Etching
74 × 53 cm

Matthew Coombes
Shear Descent
Mixed media
73 × 82 cm

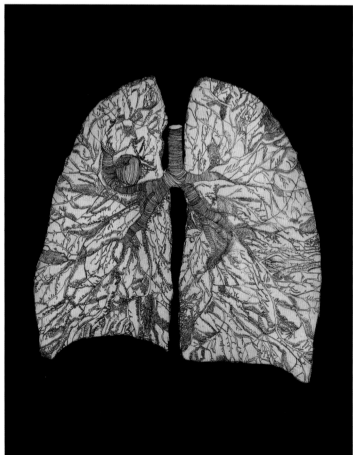

Frederick Cuming RA
Garden Under Snow
Screenprint
47 × 47 cm

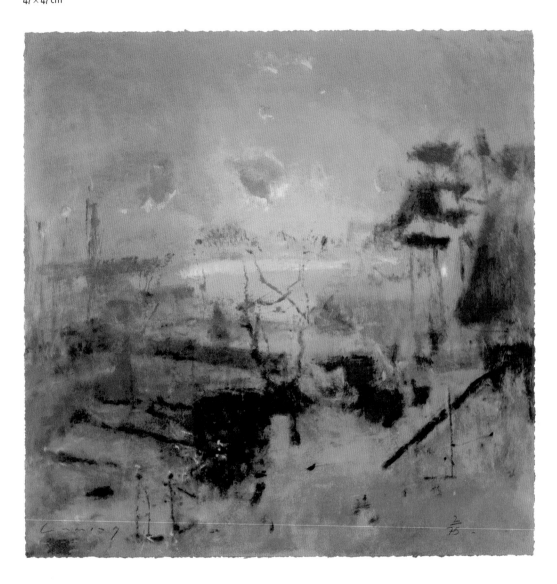

Craigie Aitchison CBE RA
Crucifixion and Mountain
Screenprint
127 × 102 cm

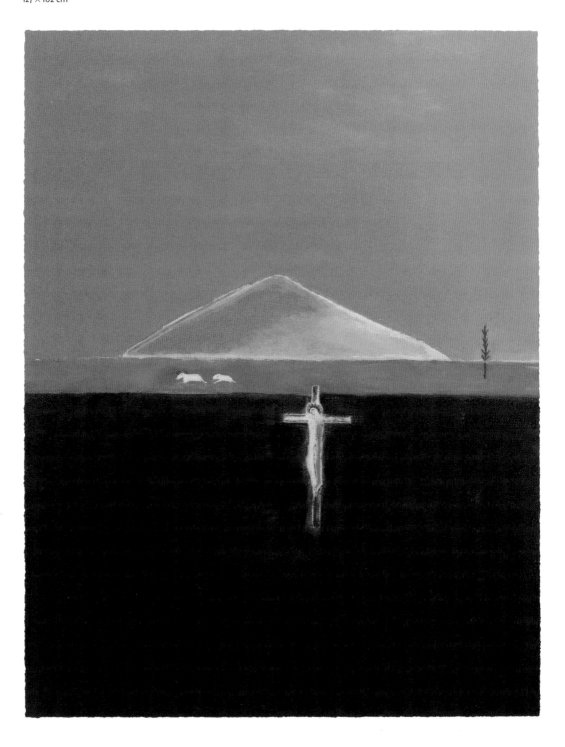

SMALL
WESTON
ROOM

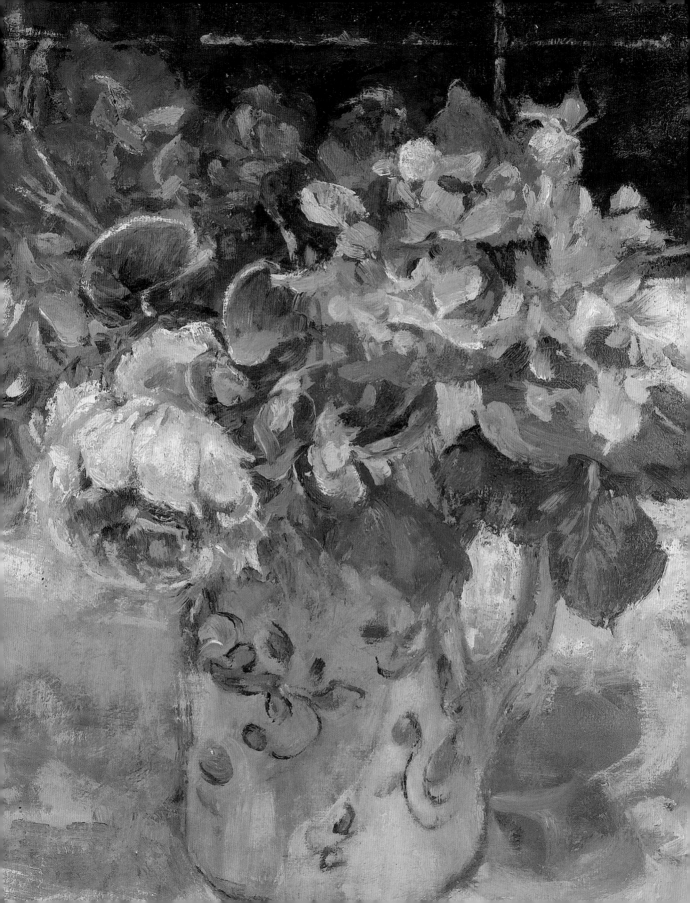

James Butler MBE RA
Dancer in a Flowered Dress
Bronze
H 46 cm

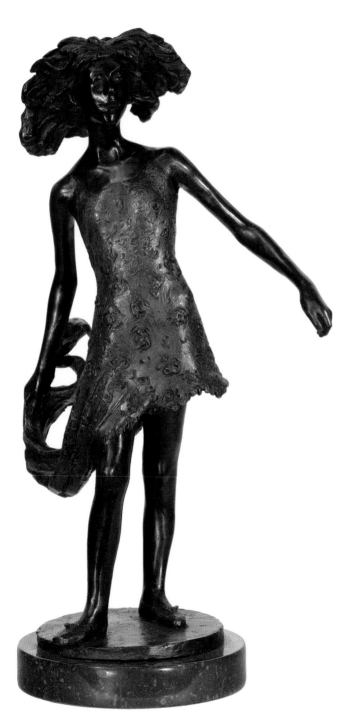

Leonard Manasseh OBE RA
Heavenly Landscape with Sun and Moon
Black ink
27 × 32 cm

Sir Nicholas Grimshaw CBE PRA
Estuary II
Etching
38 × 48 cm

Diana Armfield RA
Flowers in June in the Moustier Jug
Oil
29 × 27 cm

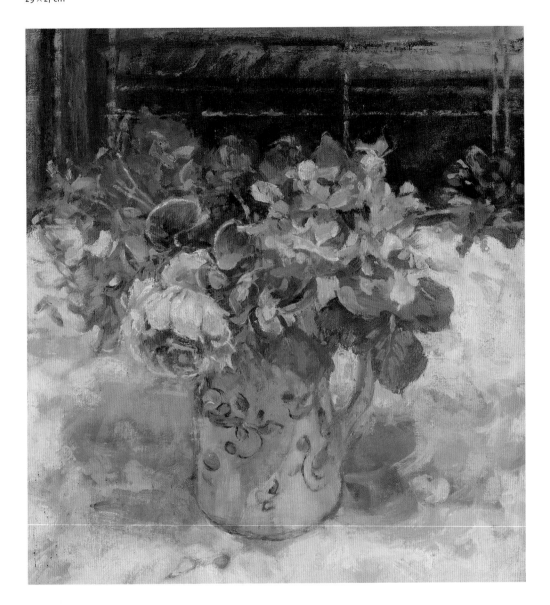

Bernard Dunstan RA
Dressing, Dark Morning
Oil
47 × 49 cm

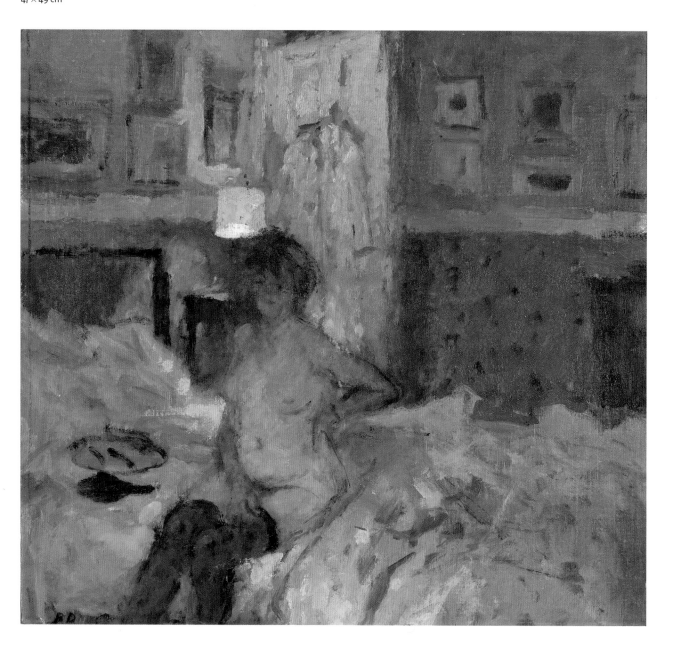

Lilo Fromm
Out of Time
Watercolour and gouache
17 × 16 cm

David Fawcett
Discussing Beryl's Bypass
Acrylic
33 × 38 cm

Peter Layzell
Sirens
Oil
47 × 37 cm

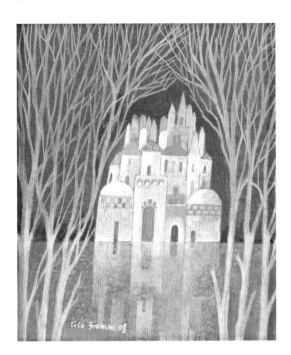

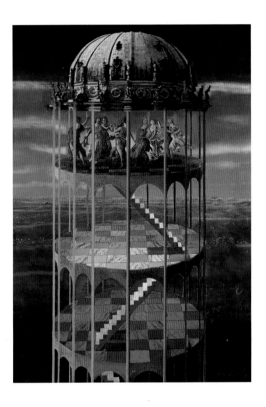

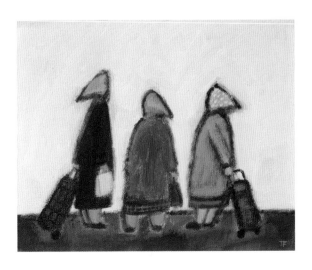

Jean Palmer
Doorway – Dark Theatre
Oil
30 × 37 cm

Lesley O'Reilly
Eira's Shoes
Screenprint
29 × 34 cm

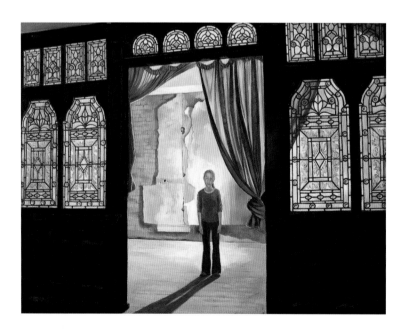

John Peace
Eric's Cafe
Oil
42 × 52 cm

Matthew Green
Untitled
Screenprint
26 × 21 cm

Maurice Sheppard
A Journey through Time,
Light and Space in Wales
Oil
45 × 52 cm

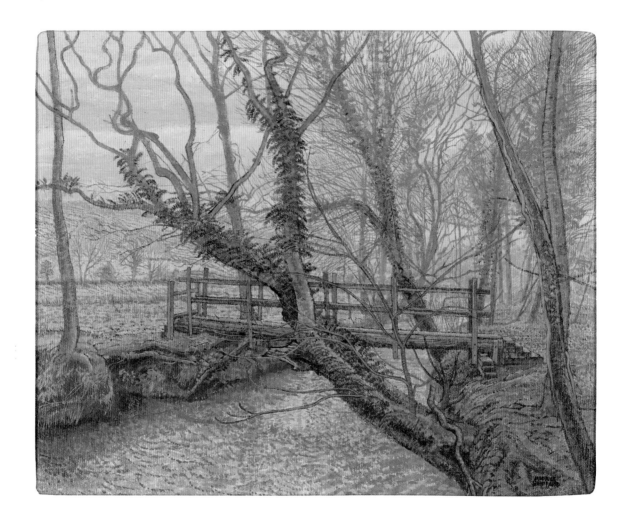

Jennifer Durrant RA
Awake, from a Series, Ghirlanda (Diptych)
Acrylic
206 × 274 cm

Cy Twombly Hon RA
The Rose
Acrylic
252 × 740 cm

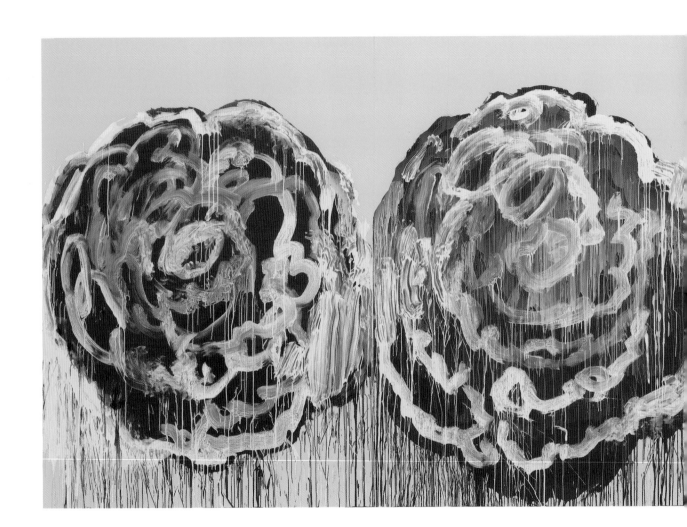

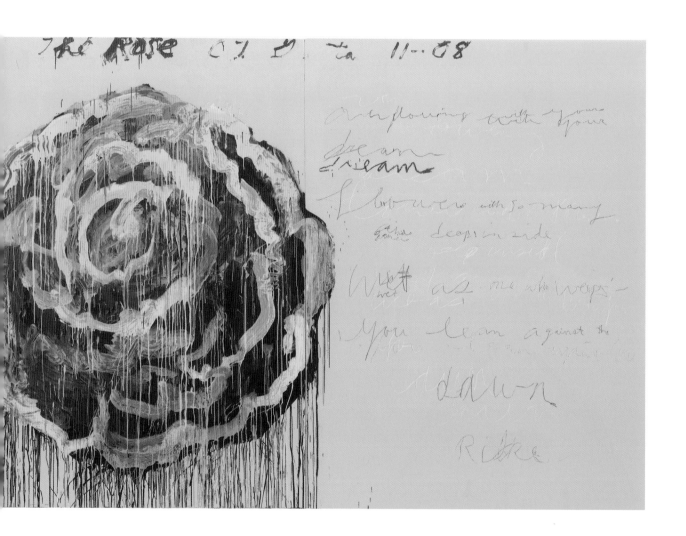

Jeffery Camp RA
Beachy Head
Oil
60 × 46 cm

Philip Sutton RA
Breeze of the Morning!
Oil
80 × 80 cm

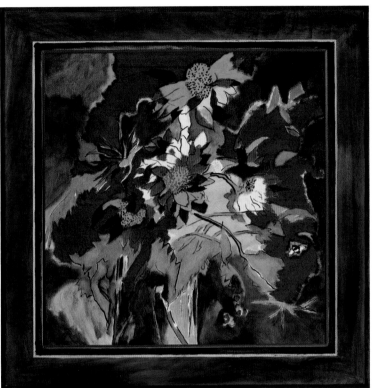

Dr Leonard McComb RA
Zarrin Sleeping
Watercolour
150 × 210 cm

Humphrey Ocean RA
Lapis
Oil
92 × 73 cm

Tracey Emin RA
17 I want it back, that feeling again
Oil
152 × 183 cm

Anthony Whishaw RA
Downstream Thaw
Acrylic
113 × 133 cm

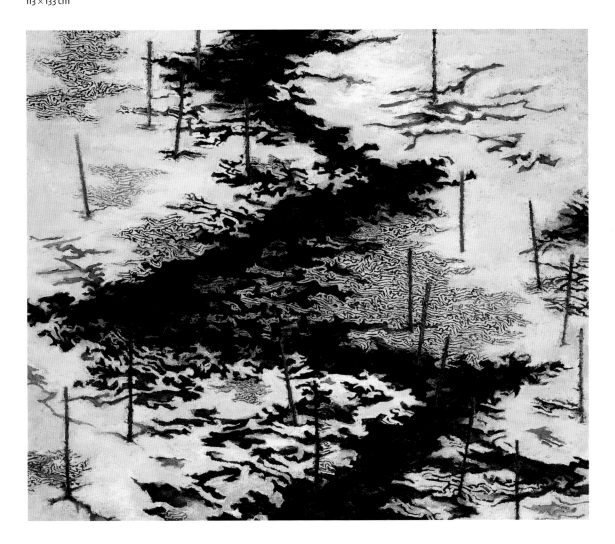

Stephen Chambers RA
Aracuria
Oil
60 × 70 cm

Stephen Chambers RA
Everyman
Oil
60 × 70 cm

Prof Maurice Cockrill RA
Old Demons Playing
Acrylic
180 × 120 cm

Frank Bowling OBE RA
Chinese Chance
Acrylic
178 × 75 cm

Lisa Milroy RA
Summer Breeze
Oil
140 × 183 cm

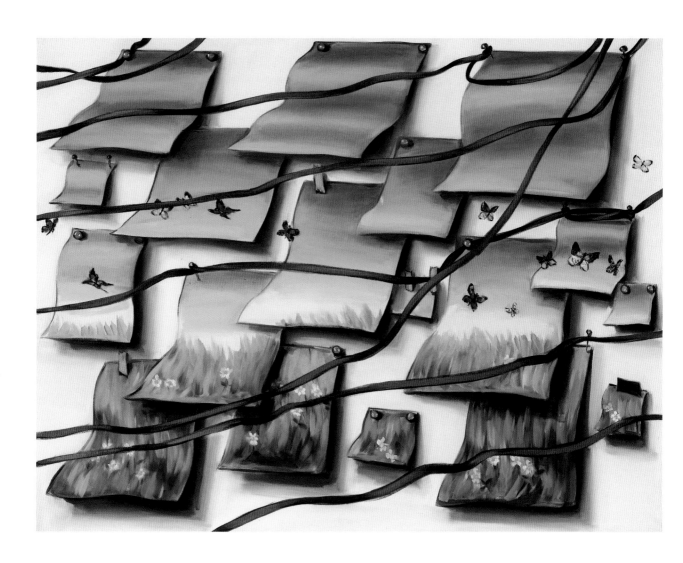

Michael Kidner RA
Brillig
Pencil
69 × 98 cm

Gus Cummins RA
Opposition
Oil
175 × 175 cm

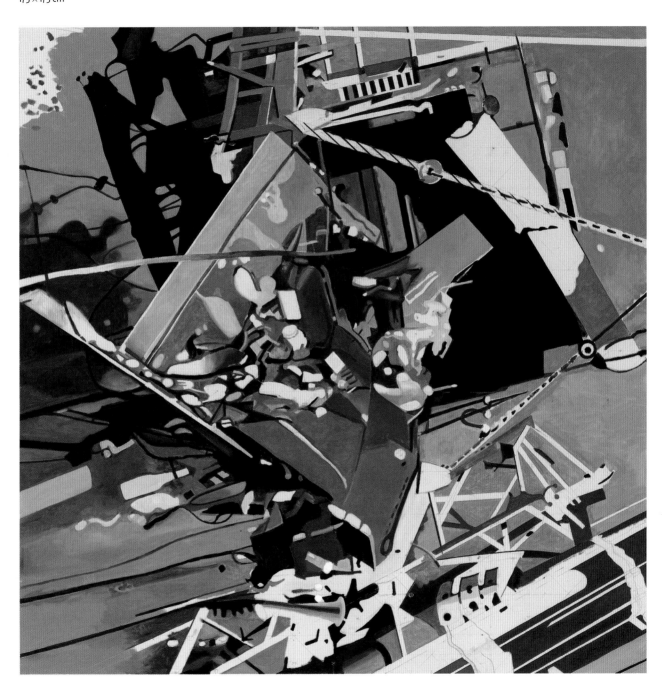

Michael Landy RA
H.2.N.Y. Dying Piano Plays Its Last Note
Oil stick
152 × 122 cm

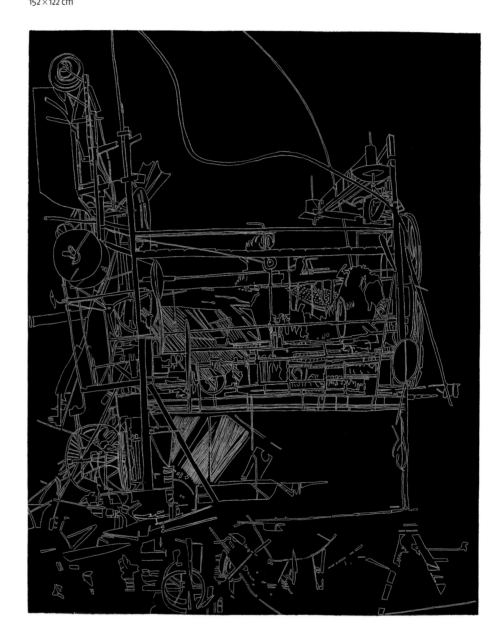

Joe Tilson RA
Conjunction Sangiovese, Arco
Oil
160 × 190 cm

Gillian Ayres OBE RA
The Sun Shone from a Different Place
Oil
199 × 199 cm

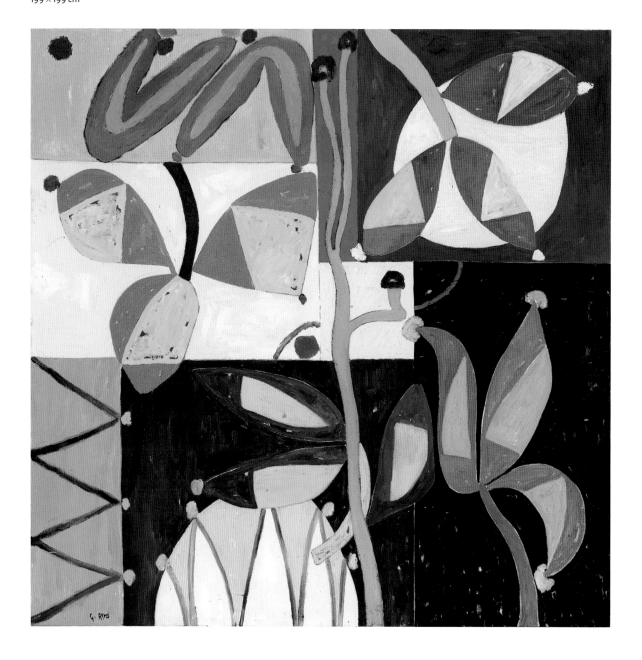

Michael Craig–Martin CBE RA
Untitled (Desire)
Acrylic on aluminium
200 × 325 cm

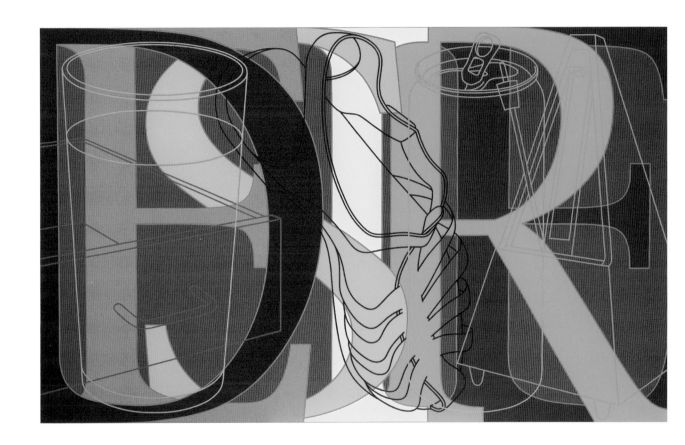

Albert Irvin RA
Dante I
Acrylic
232 × 153 cm

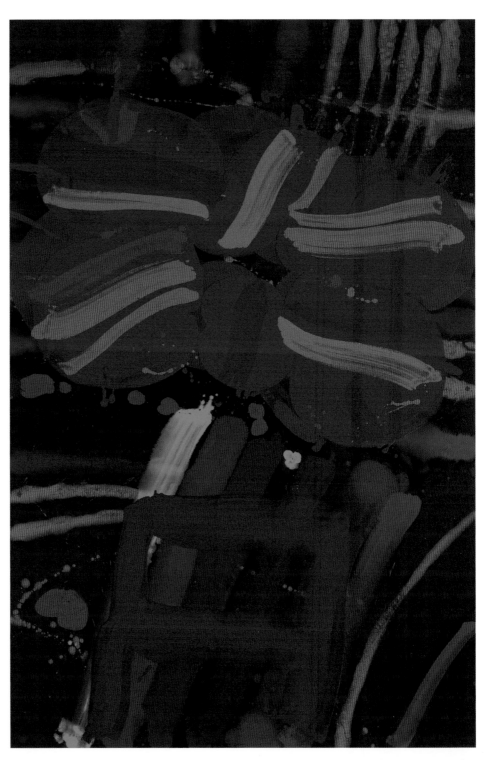

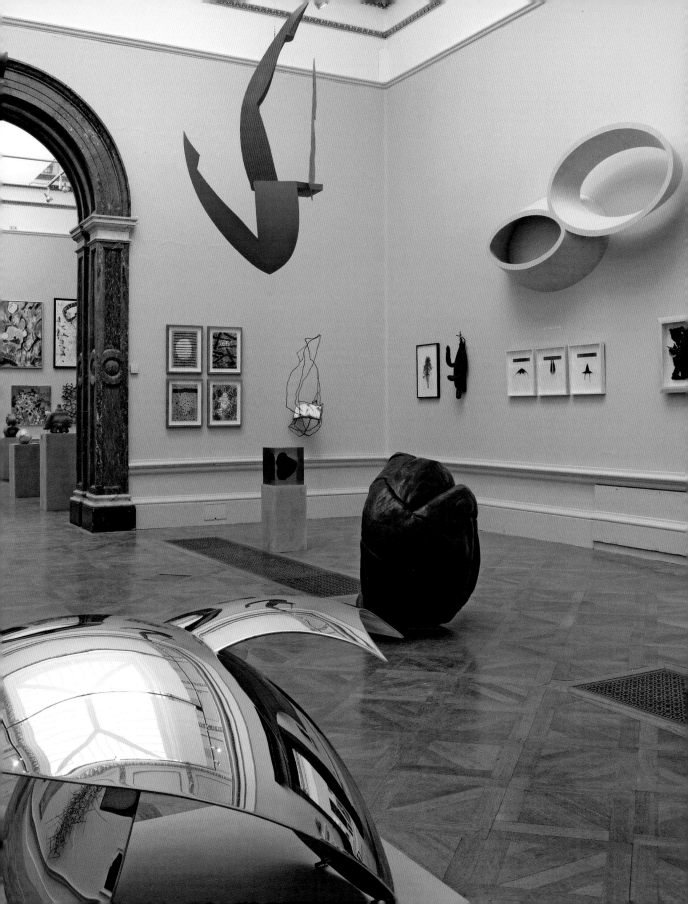

David Nash OBE RA
Cuts Up Cuts Down, 2009
Limewood
H 160 cm

Ann Christopher RA
Silent Light 2
Stainless steel
H 11 cm

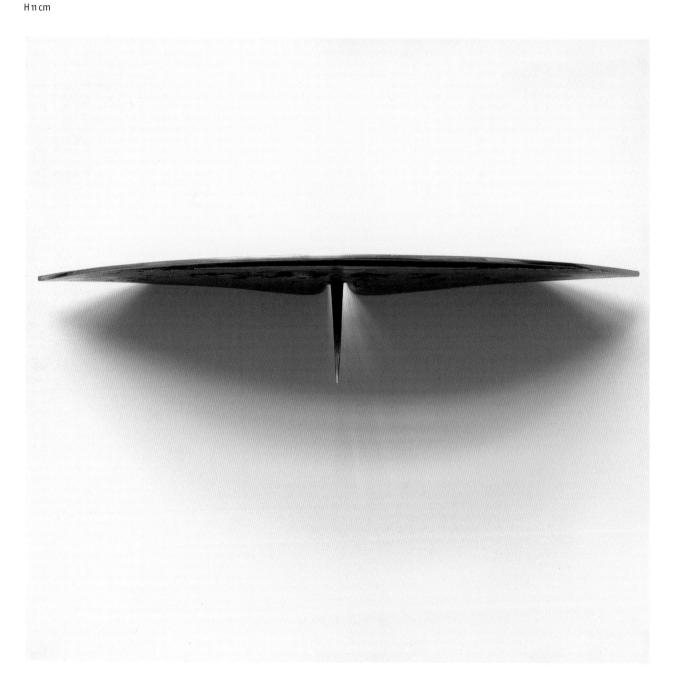

Richard Wilson RA
Joint's Jumping
Photograph wire print
110 × 90 cm

Beate Gütschow
S#2
Mixed media
177 × 210 cm

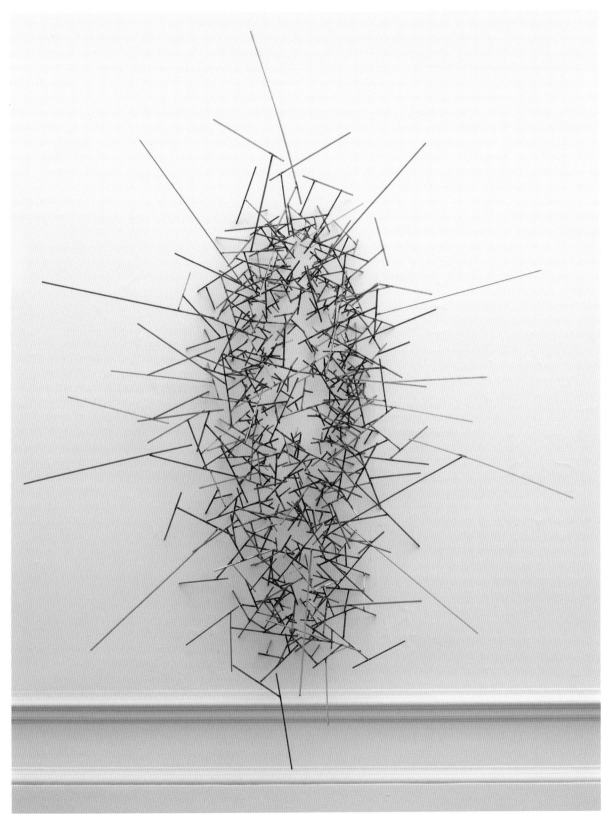

Antony Gormley OBE RA
Quantum Void VI 2009
Steel
370 × 275 cm

Tacita Dean RA
Small Study for Monkey Puzzle II
Mixed media
40 × 25 cm

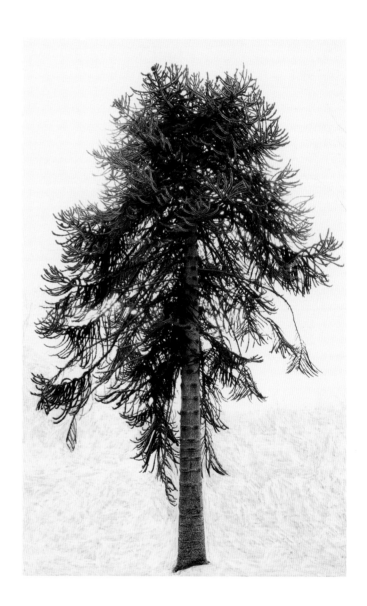

Bill Woodrow RA
Tundra I
Mixed media
51 × 41 cm

Mick Moon RA
Tree Line
Mixed media
122 × 122 cm

Richard Long RA
Mind out of Time
Mixed media
70 × 58 cm

Alison Wilding RA
Crossing
Ink on Japanese paper and brass
177 × 188 cm

John Carter RA
Four Identical Shapes
Brass
40 × 40 cm

Prof Ian McKeever RA
Assembly Gouache (ref: G–2008–9)
Gouache and pencil
62 × 90 cm

Cornelia Parker
Bullet Drawing
Lead
66 × 66 cm

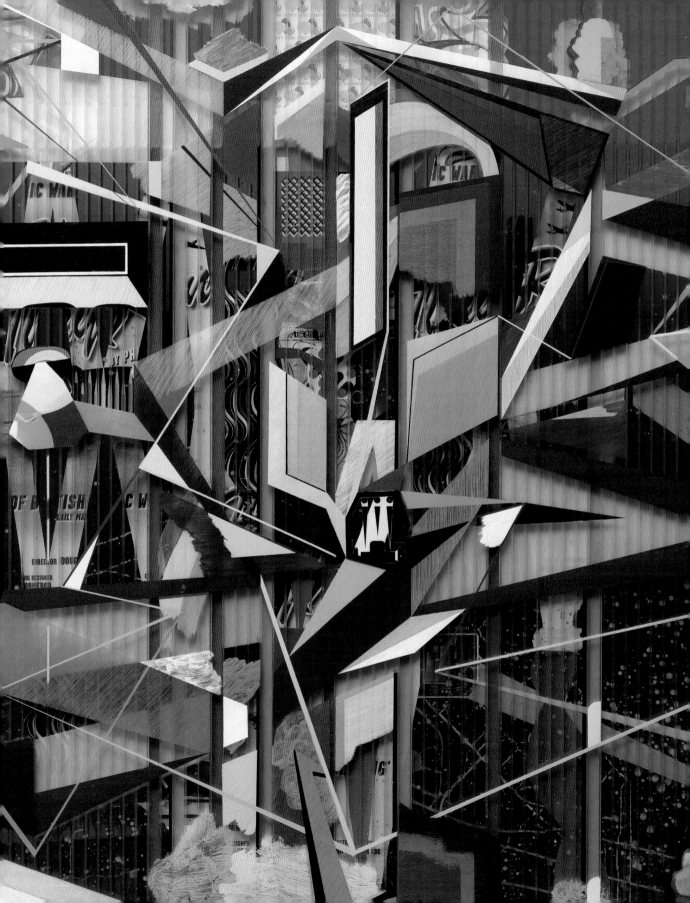

Melanie Miller
Lady Bee Hydrangea
Oil
55 × 55 cm

David Hegarty
Brecon Beacon
Oil
64 × 71 cm

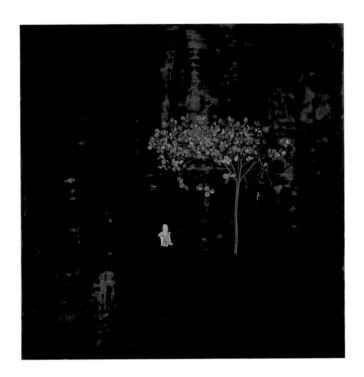

Prof William Alsop OBE RA
I Wish My Garden Was Really Like This
Oil
122 × 122 cm

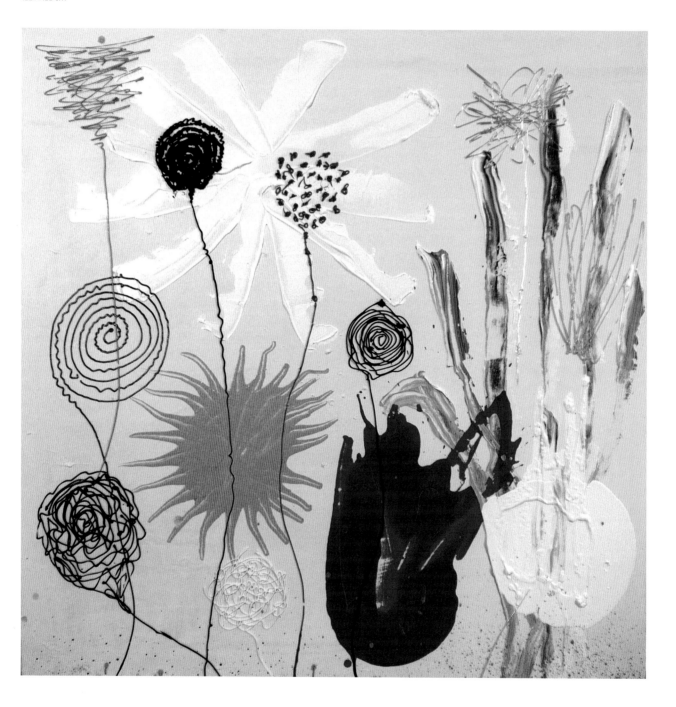

Angela Braven
Cannonball Tree, Seychelles
Acrylic
101 × 213 cm

Matthew Kolakowski
Blue Drift
Oil
205 × 120 cm

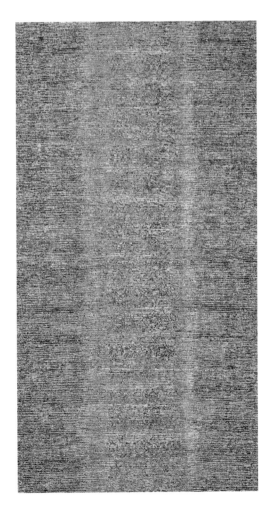

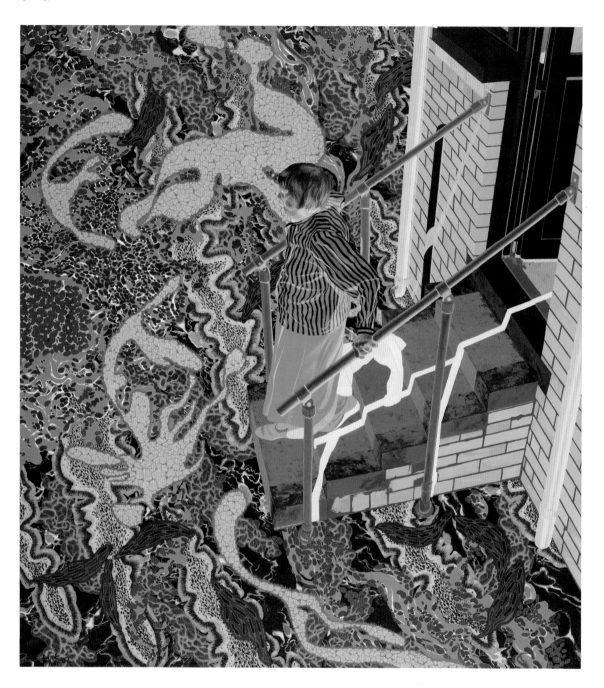

Arthur Wilson
Crossing Currents
Mixed media
110 × 100 cm

Geoffrey Clarke RA
Post Inert Phase II, Cube B, 1968
Cast aluminium
H 67cm

Derek Boshier
Shot in the Arm Cowboy
Acrylic
183 × 122 cm

VI

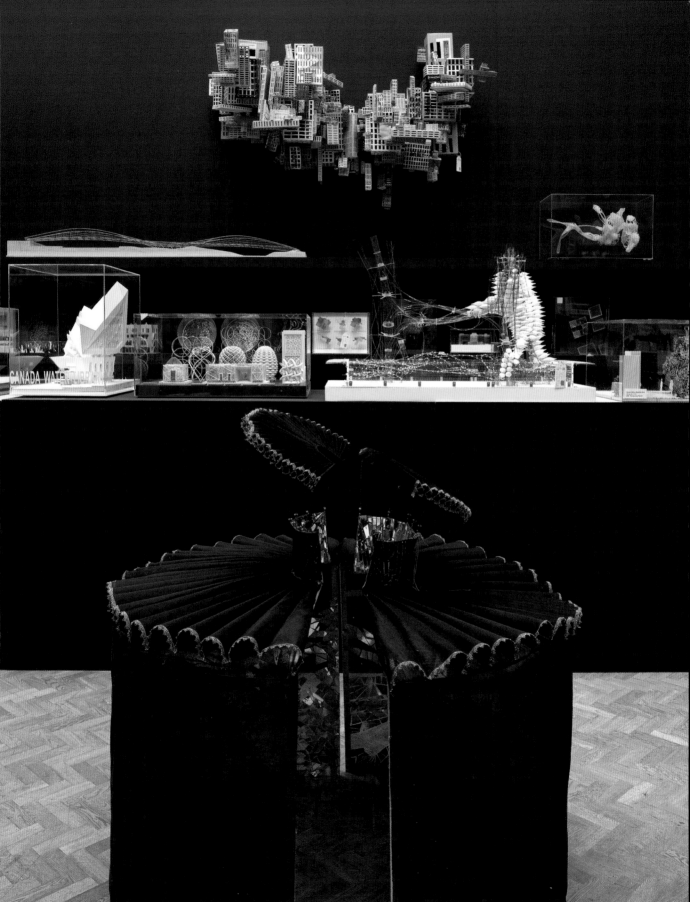

Prof Sir Peter Cook RA
Hidden City
Mixed media
110 × 110 cm

Prof David Chipperfield CBE RA (David Chipperfield Architects)
Section through the East Wing, the Neues Museum, Museum Island, Berlin
Print
70 × 140 cm

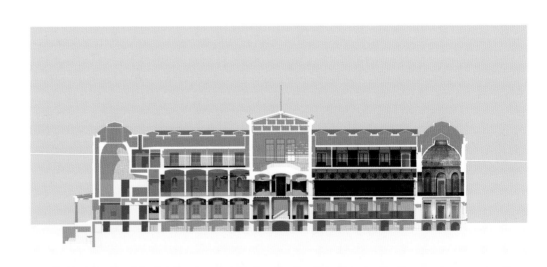

Edward Cullinan CBE RA
A Future for Letchworth
Ink and graphite
90 × 70 cm

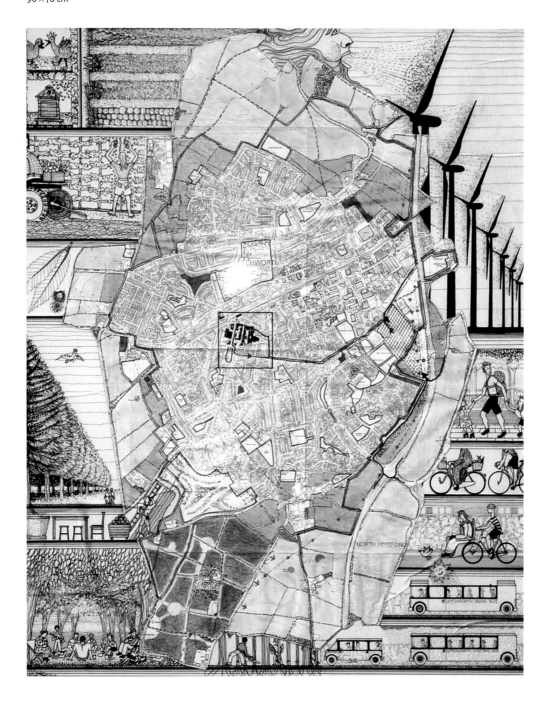

Michael Manser CBE RA
Private Residence, Isle of Wight, Sectional Model, Scale 1:50
Model
H 62 cm

Sir Michael Hopkins CBE RA (Hopkins Architects)
Maharashtra Cricket Association
Model
H 120 cm

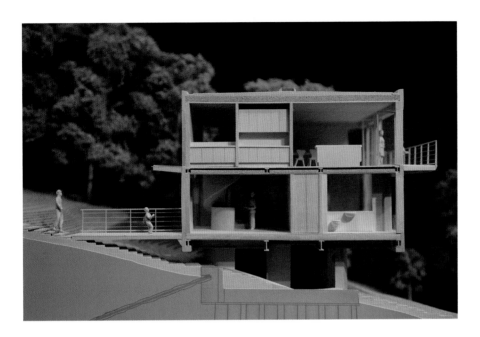

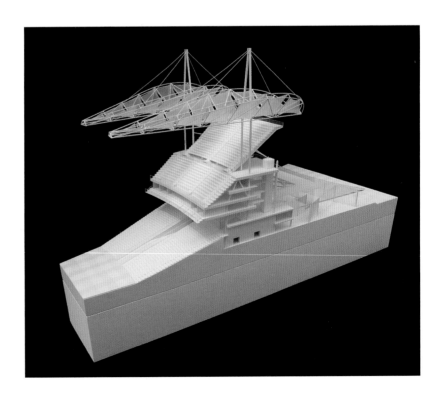

**Spencer de Grey CBE RA
(Foster and Partners)**
Yacht Club de Monaco
Model
H 47 cm

Piers Gough CBE RA (CZWG Architects)
Canada Water Library Model
Model
H 75 cm

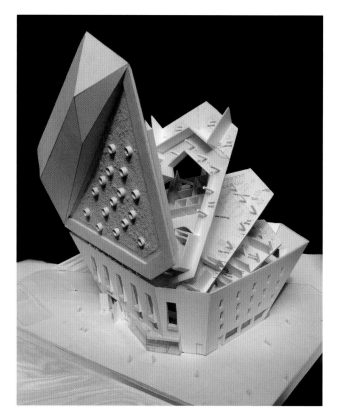

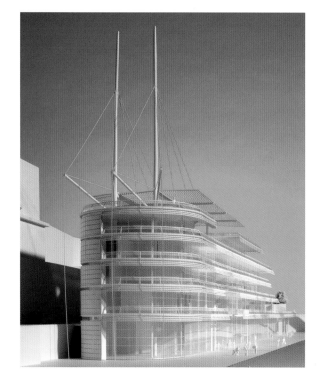

Lord Rogers of Riverside CH RA (Rogers Stirk Harbour and Partners)
Santa Maria del Pianto Underground Station Roof: Concept Sketches
Pen and tracing paper
31 × 139 cm

Prof Gordon Benson OBE RA
Making Space IV
Print
29 × 59 cm

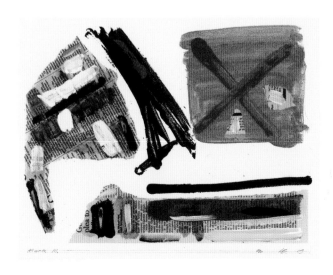

Paul Koralek CBE RA
i-Hub Concept 3
Pencil
20 × 40 cm

Prof Ian Ritchie CBE RA
Scotland's Home of Tomorrow
Etching
48 × 36 cm

Eric Parry RA (Eric Parry Architects)
Stair Design Working Model, Final State
Model
H 47 cm

Sir Richard MacCormac CBE RA (MJP Architects)
Harrow Further Education College (detail)
Model
H 124 cm

Lord Foster of Thames Bank OM RA (Foster and Partners)
Schools for Sierra Leone: Study Model
Model
H 60 cm

Prof Trevor Dannatt RA (Dannatt, Johnson Architects)
Mezzanines and Basement Offices: New Spaces for the Royal Academy at Burlington Gardens (detail)
Photograph
42 × 30 cm

Tadao Ando Hon RA
Pulitzer Foundation for the Arts, St Louis, 2001 (detail)
Photograph
20 × 240 cm

Renzo Piano Hon RA (Renzo Piano Building Workshop)
The California Academy of Science (Study of the Roof)
Model
H 25 cm

Chris Wilkinson OBE RA (WilkinsonEyre.Architects)
Apraksin Dvor Masterplan
Model
H 58 cm

Eva Jiricna CBE RA (Eva Jiricna Architects)
William and Judith Bollinger Jewellery Gallery, Victoria and Albert Museum
Light box
H 90 cm

Zaha Hadid CBE RA
Kartal Pendik Masterplan, Istanbul, Turkey
Model
H 21 cm

VII

Sonia Lawson RA
Night Drive
Oil
130 × 109 cm

Flavia Irwin RA
Split Infinitive 8
Acrylic
70 × 90 cm

Juliette Losq
Schema
Ink
43 × 173 cm

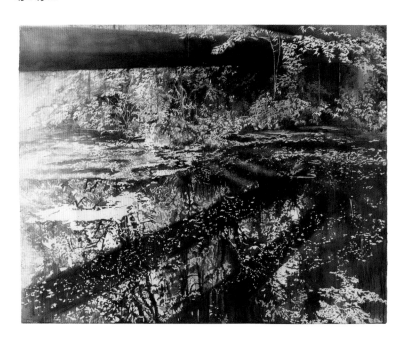

Adrian Berg RA
Hillside, from a Persian Rug
Oil
86 × 66 cm

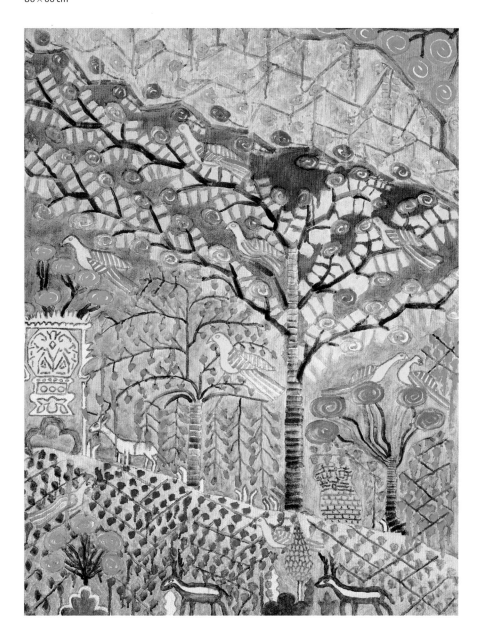

Peter Arscott
Cactus 1
Acrylic
100 × 120 cm

Ivor Abrahams RA
Lavender Border
Mixed media
36 × 60 cm

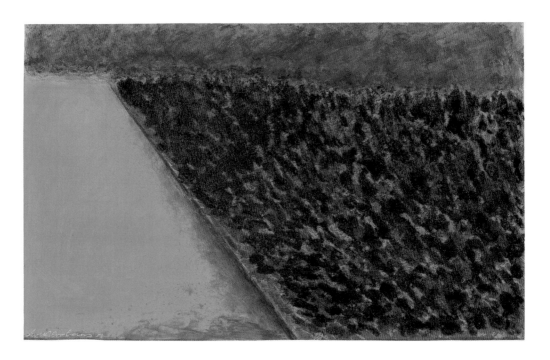

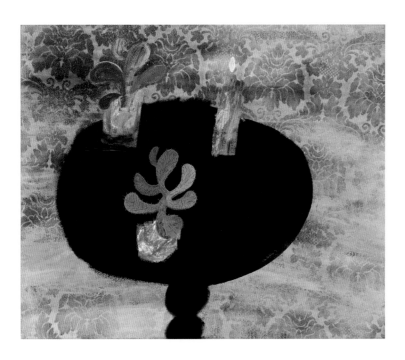

Jeffrey Dennis
The Tipping Point
Oil and charcoal
46 × 56 cm

Morgan Doyle
Japanese Landscape
Woodcut
101 × 121 cm

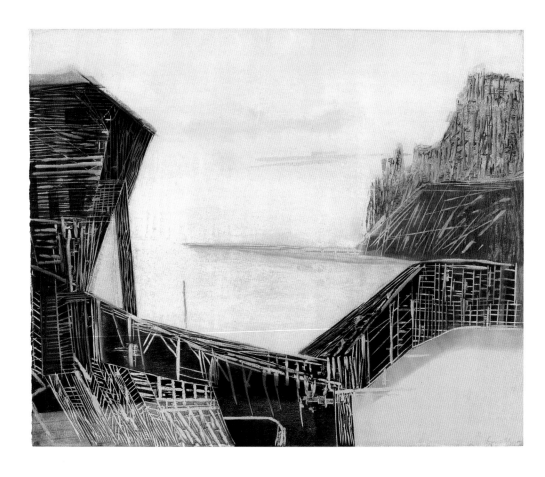

Tricia Gillman
Roundelay
Acrylic
130 × 160 cm

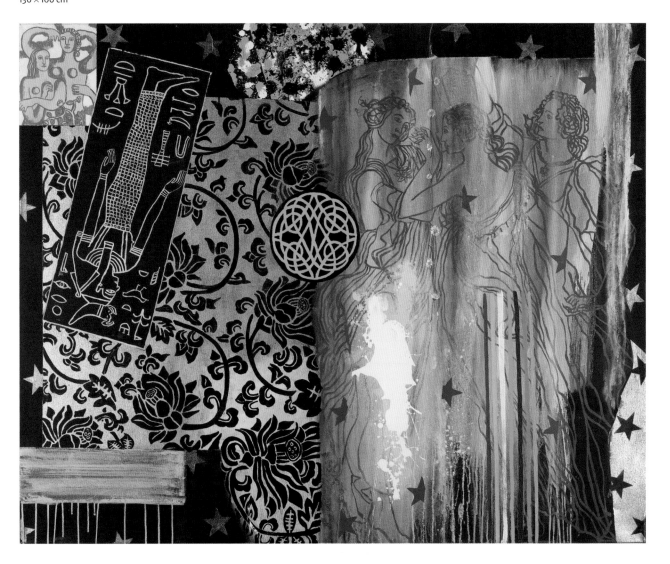

Clyde Hopkins
Bucolic Hippy Painting 2
Oil
70 × 55 cm

Yoshimi Kihara
T. Circle
Newspaper
15 × 64 cm

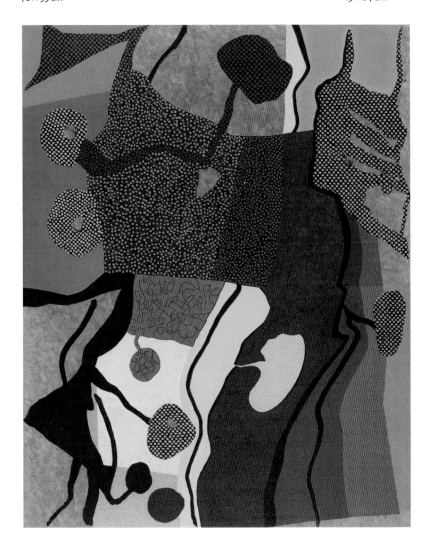

John Loker
No Return 2, 2008
Acrylic
176 × 181 cm

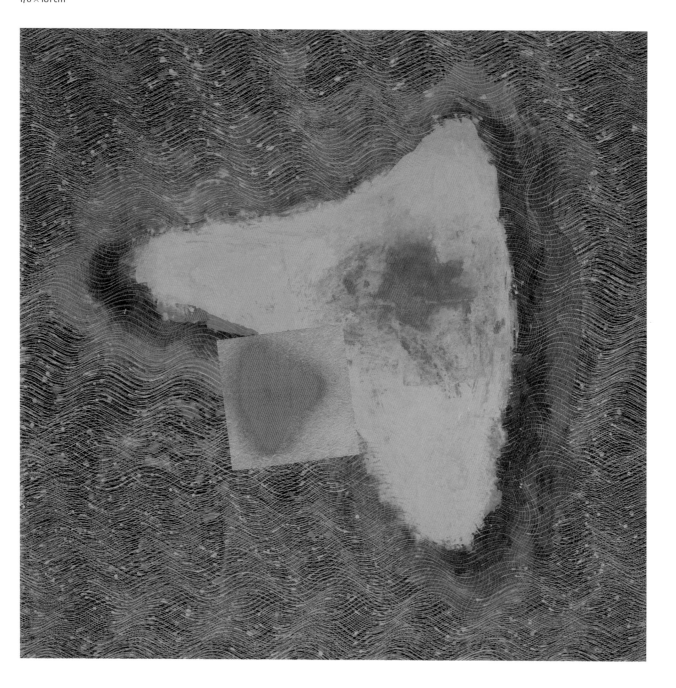

VIII

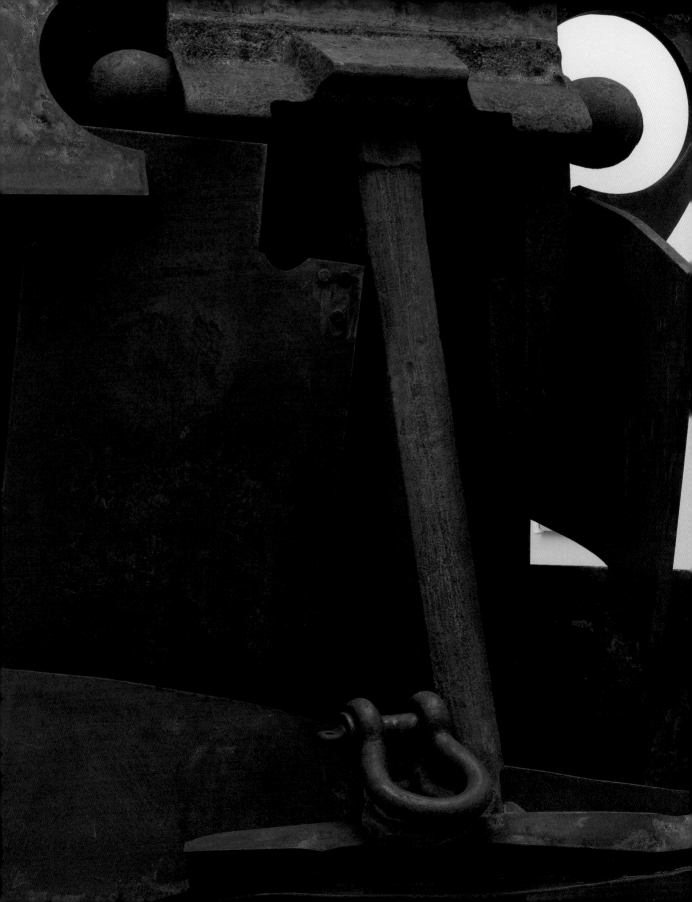

Mick Owens
Shadow Love
Gouache
61 × 66 cm

Kenneth Draper RA
Deep Waters
Mixed media
67 × 77 cm

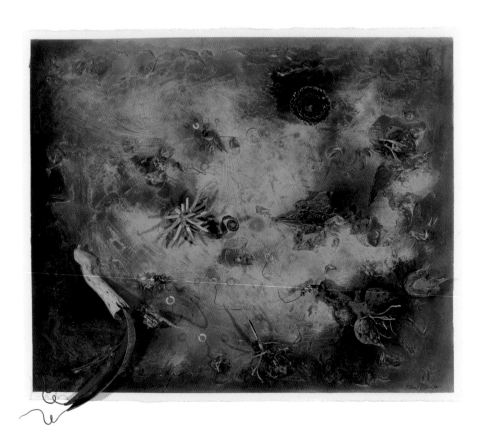

Dr Barbara Rae CBE RA
Andalusia
Mixed media
209 × 234 cm

Mary Ramsden
Tusk
Oil
167 × 190 cm

Sir Anthony Caro OM CBE RA
Erl King
Steel
H 251 cm

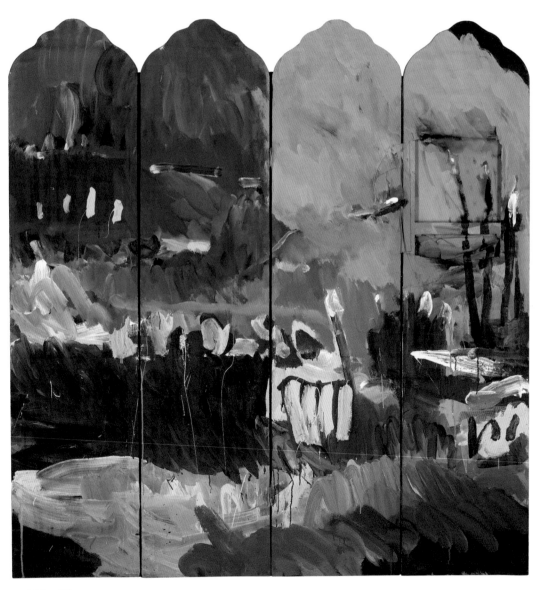

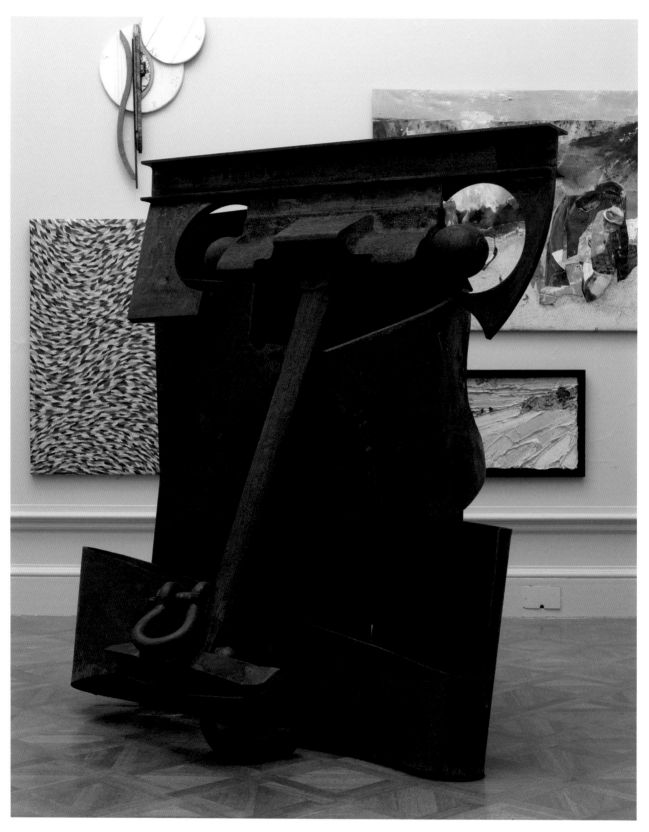

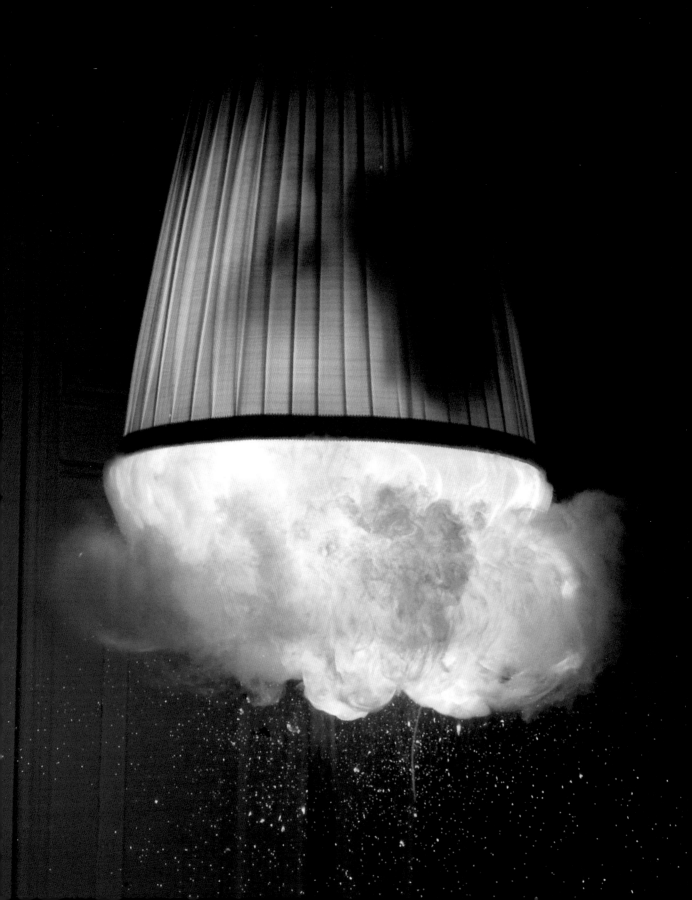

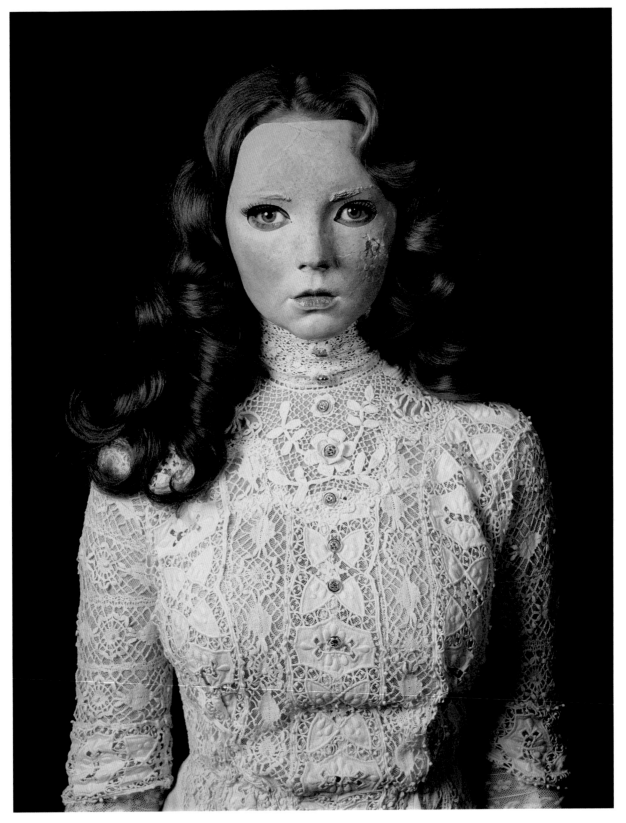

Gillian Wearing RA
Lily Cole
Photograph
61 × 51 cm

Maciej Urbanek
Angus
Print
70 × 55 cm

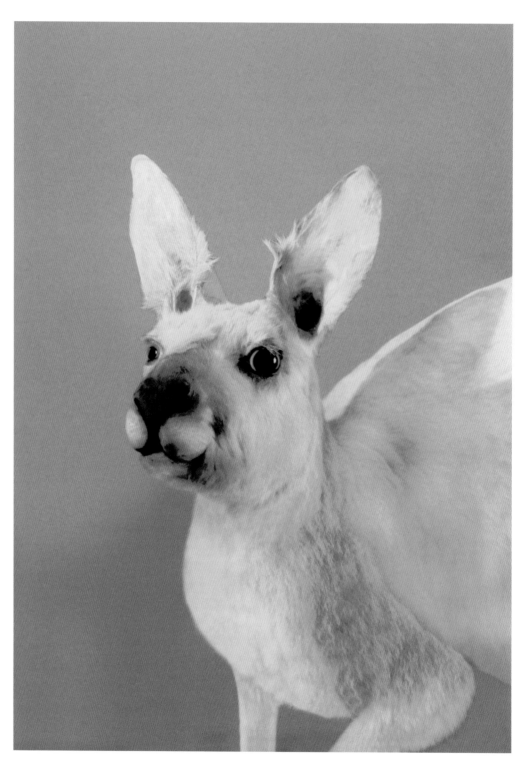

David Mach RA
Predator
Postcard collage
192 × 192 cm

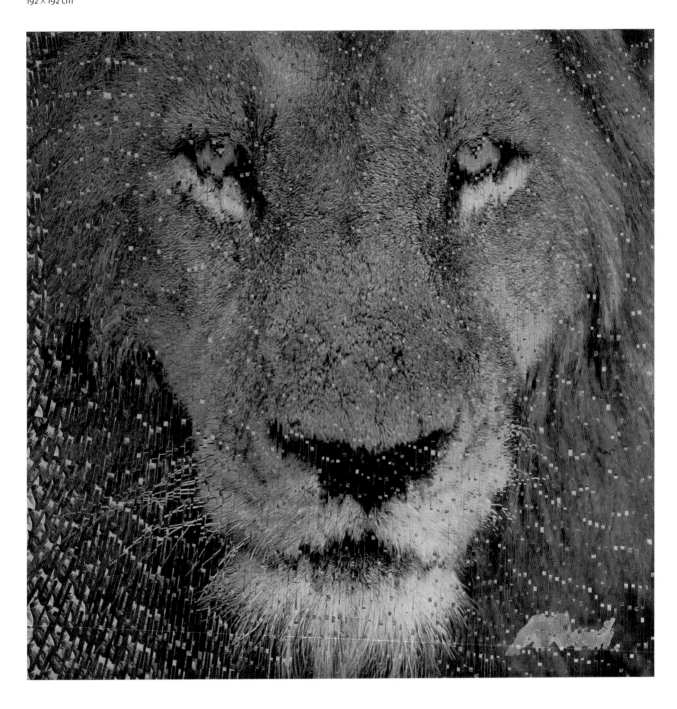

James Howard
LuckyLuckyDice.com
Digital print
70 × 100 cm

Joc, Jon & Josch
Inbetween
Lambda print
85 × 110 cm

Barton Hargreaves
Paradise Lost
Digital print
116 × 94 cm

Joschi Herczeg
Explosion 2
Lambda print
60 × 41 cm

Miyako Narita
Top 'n' Tail
Inkjet print
55 × 70 cm

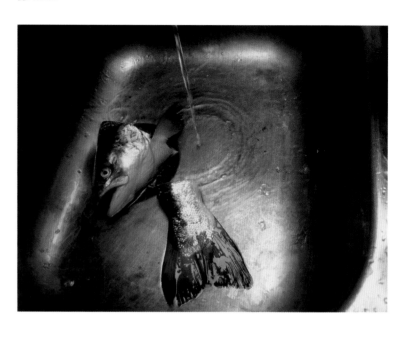

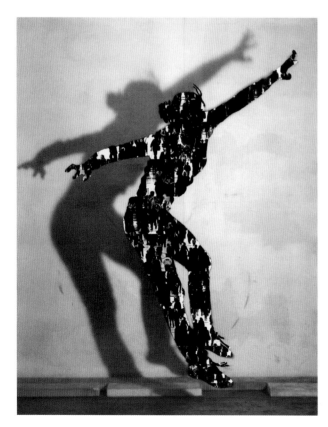

LECTURE ROOM

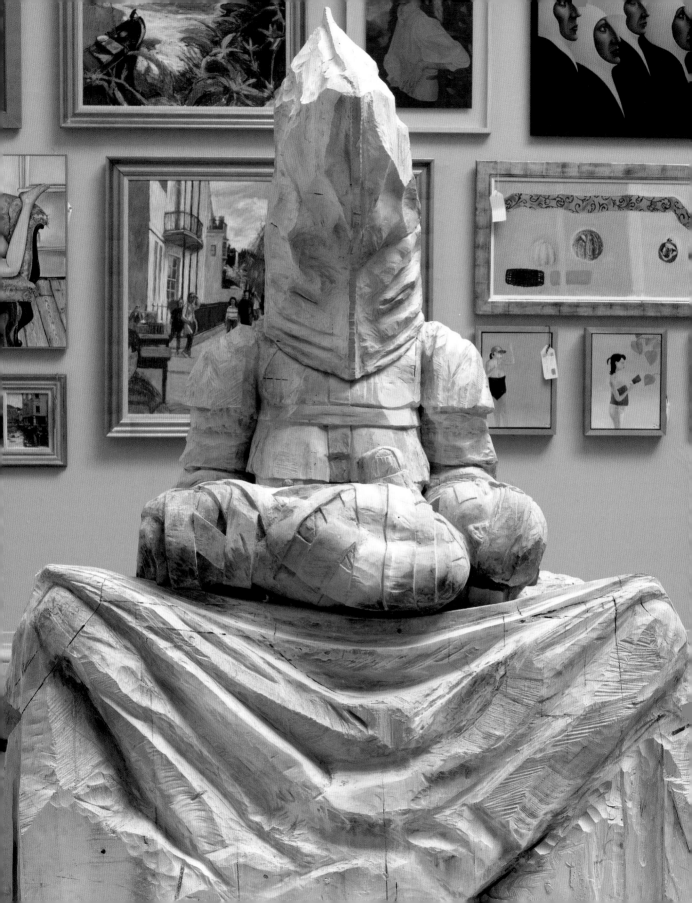

Eileen Cooper RA
Safe Passage
Oil
137 × 107 cm

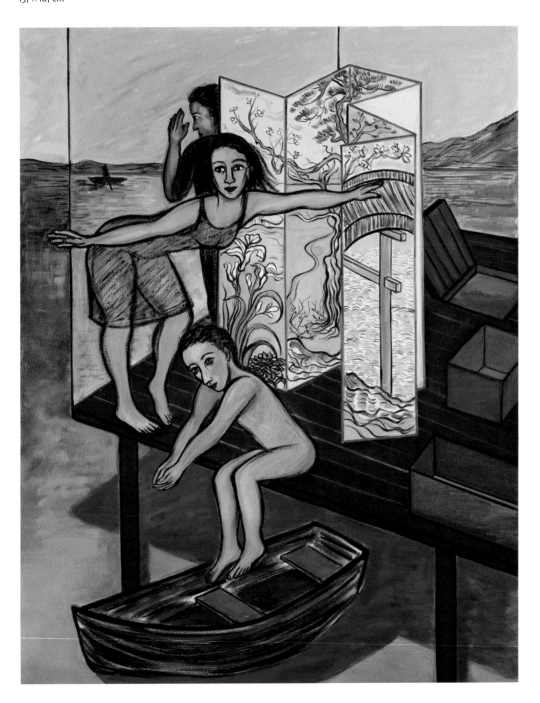

Dr David Tindle RA
Blue Bed and Cushion
Acrylic
48 × 69 cm

David Remfry MBE RA
Pictures from Storyville
Graphite and watercolour
102 × 153 cm

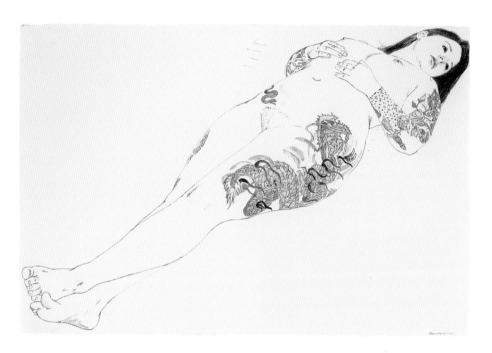

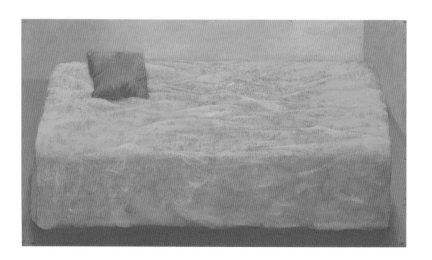

Sasha Bowles
On Top of it All
Oil
165 × 88 cm

Peter Messer
Flight
Tempera
100 × 76 cm

Mary Fedden OBE RA
Figs
Oil
60 × 50 cm

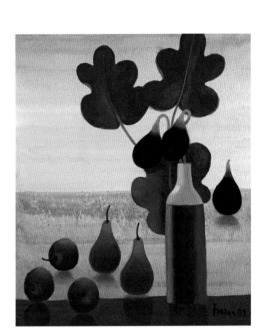

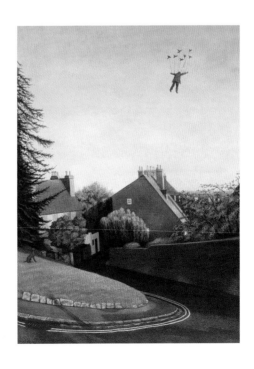

Donald Hamilton Fraser RA
Cityscape
Oil
48 × 36 cm

Prof Stephen Farthing RA
Golden Handshake
Acrylic
206 × 173 cm

Ursula McCannell
There's a Storm Coming
Oil
77 × 57 cm

Evelyn Williams
A Gust of Wind. Arrival no: 1, 2006
Oil
122 × 122 cm

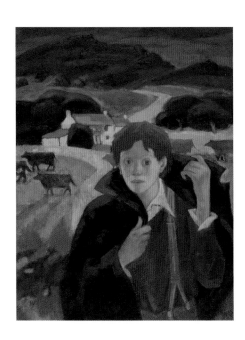

George Underwood
Silent Reflection
Oil
94 × 120 cm

Carl Randall
Family in the Country
Oil
33 × 24 cm

Michael Debono
Second Sight
Oil
125 × 167 cm

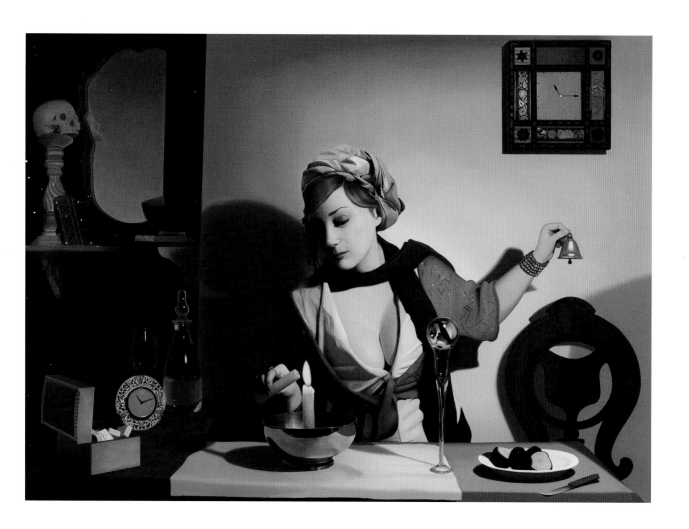

Olwyn Bowey RA
Geese through Bulrushes
Oil
134 × 120 cm

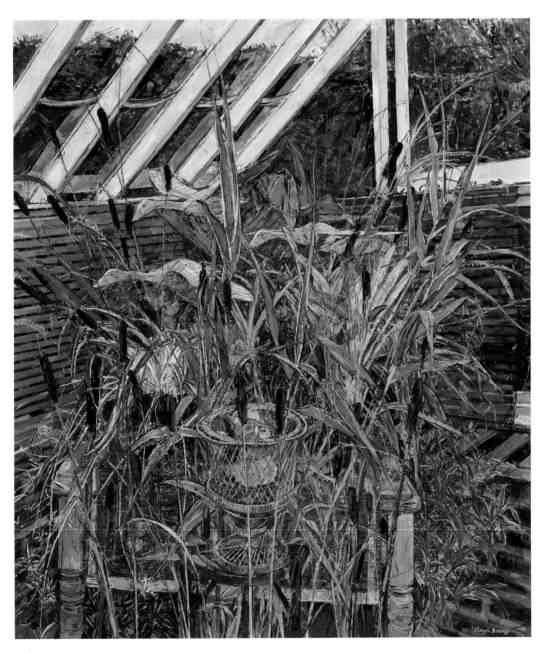

Anthony Eyton RA
Autumn Grasses
Oil
127 × 150 cm

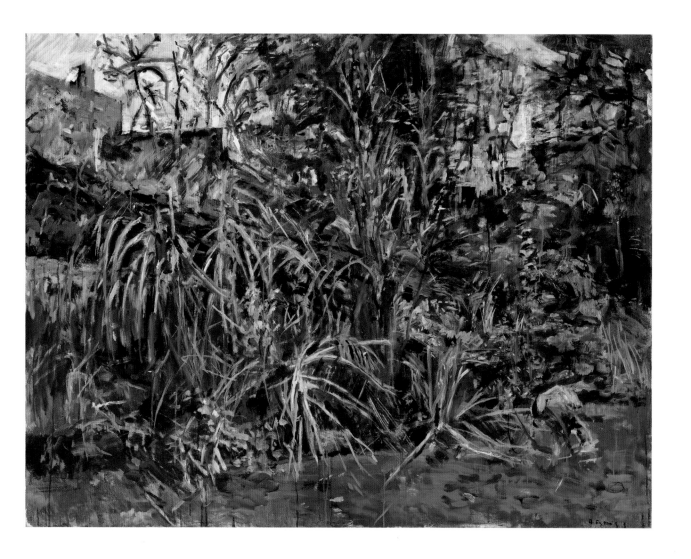

Dr John Bellany CBE RA
Bright Reward
Oil
172 × 152 cm

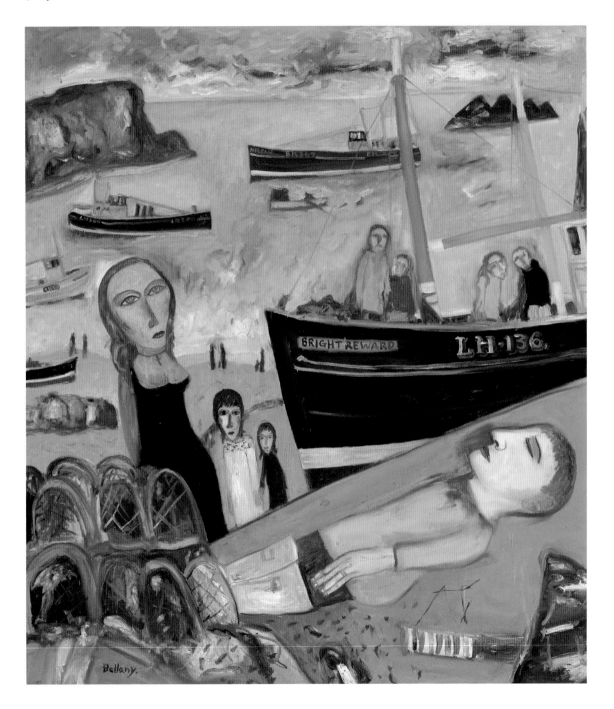

Mick Rooney RA
Hornby Train Game
Oil
59 × 44 cm

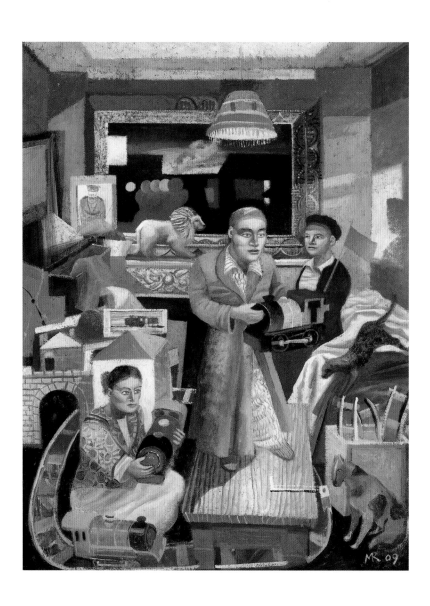

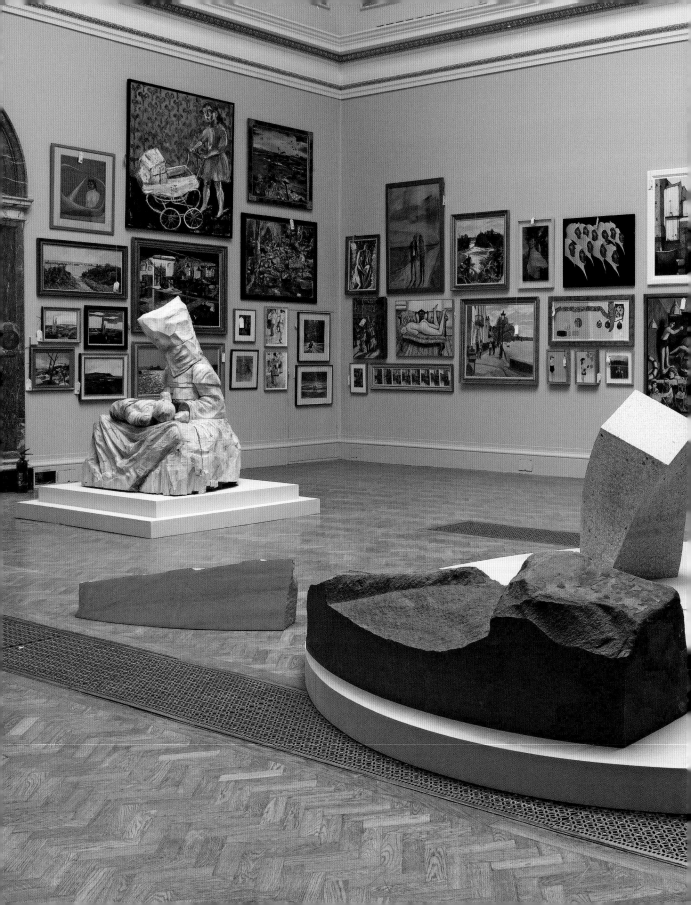

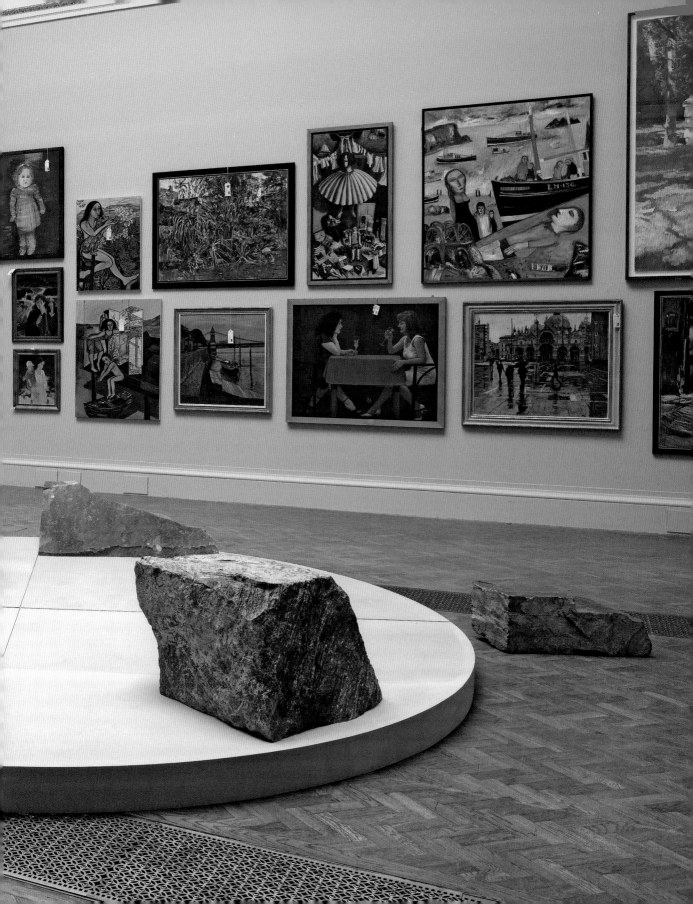

Prof Ken Howard RA
Venetian Octet
Oil
24 × 152 cm

Christopher Le Brun RA
Composition with Circles
Bronze
H 29 cm

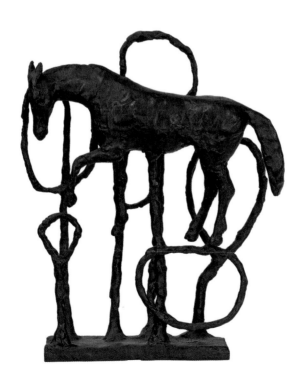

Dame Elizabeth Blackadder DBE RA
Pomegranates, Melons and Silk Ribbon
Oil
66 × 117 cm

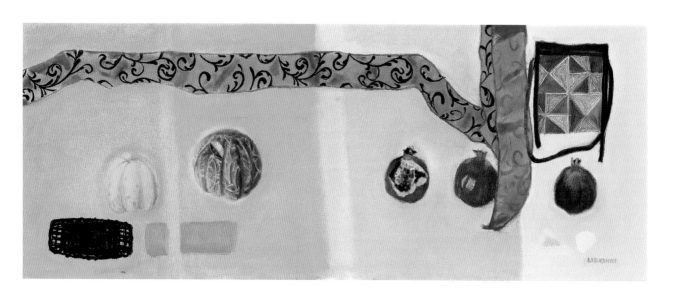

WOHL CENTRAL HALL

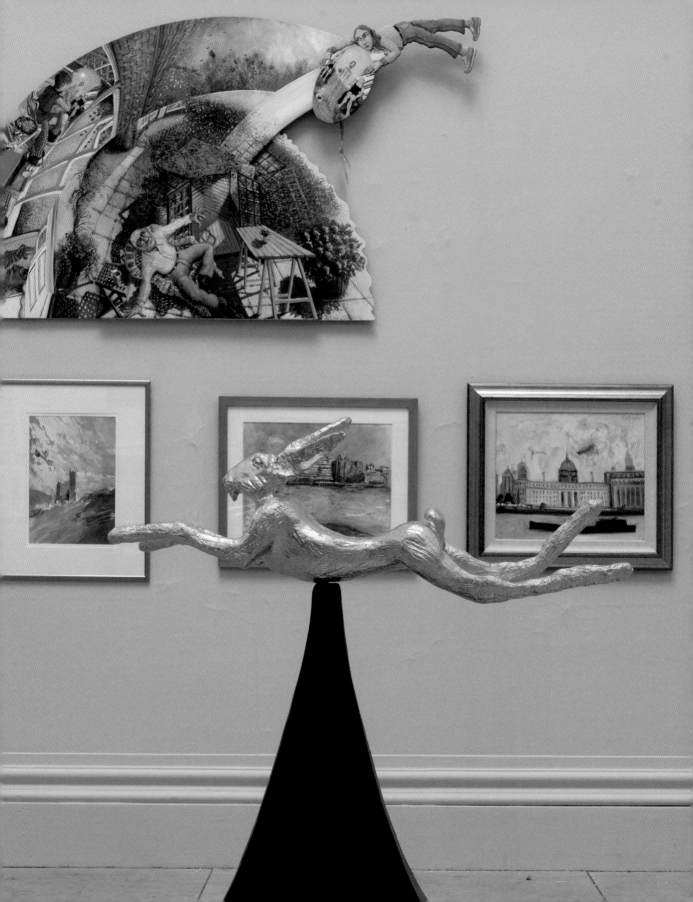

Ralph Brown RA
Queen
Bronze
H 198 cm

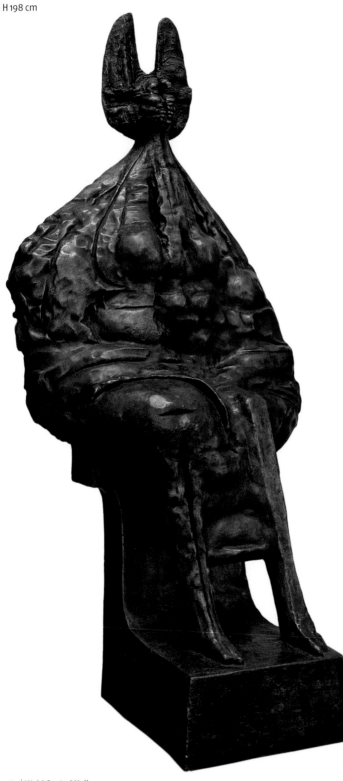

Leonard Rosoman OBE RA
Falling Christmas Tree
Acrylic
108 × 81 cm

Ben Levene RA
Looking through the Mirror
Oil
92 × 97 cm

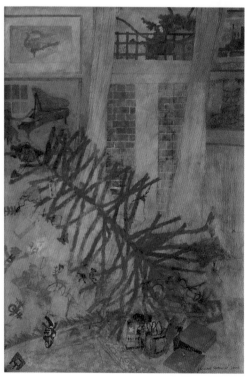

William Bowyer RA
Chiswick House
Oil
117 × 90 cm

Frederick Gore CBE RA
September
Oil
103 × 85 cm

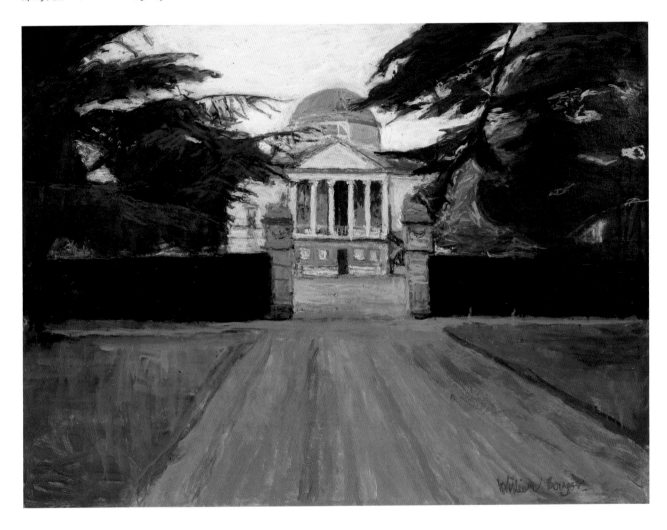

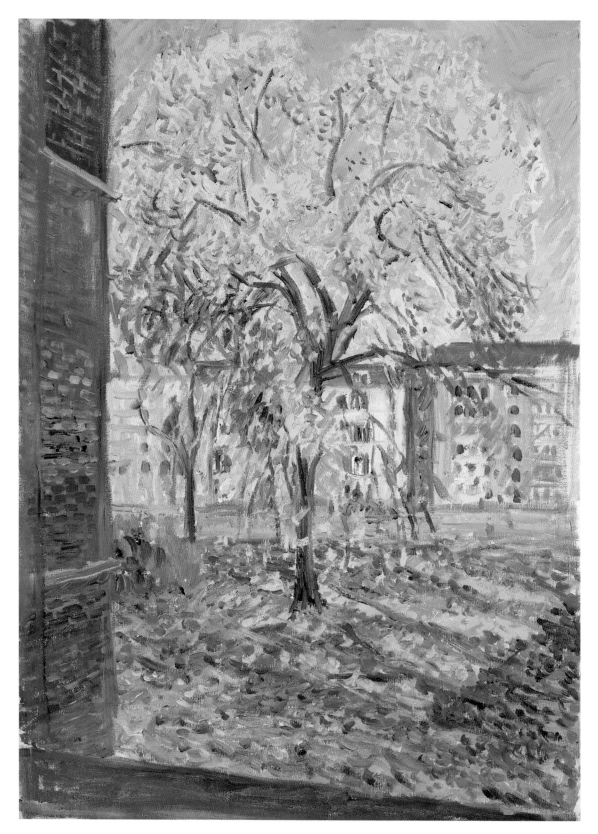

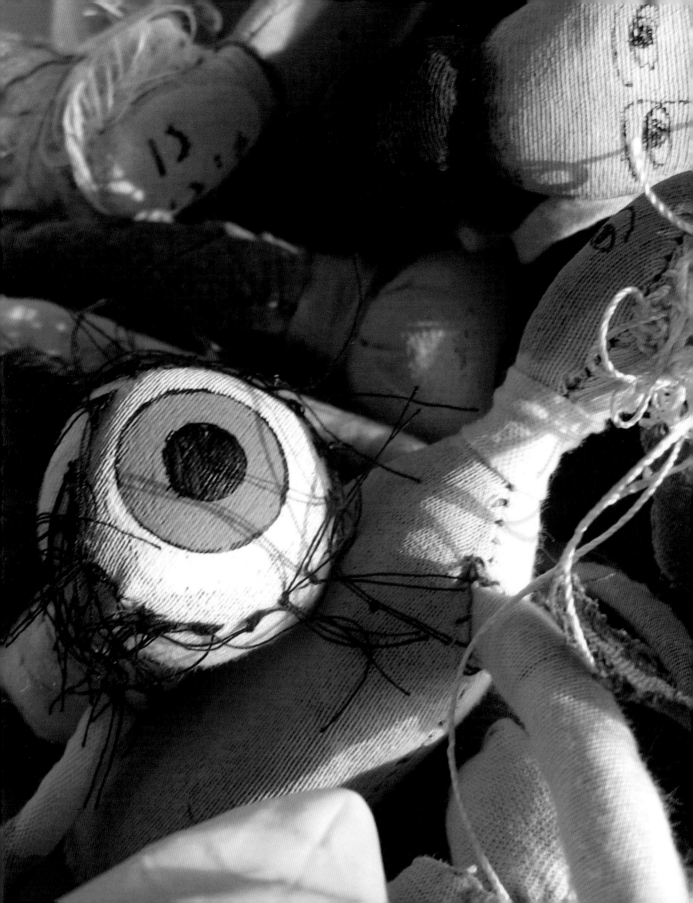

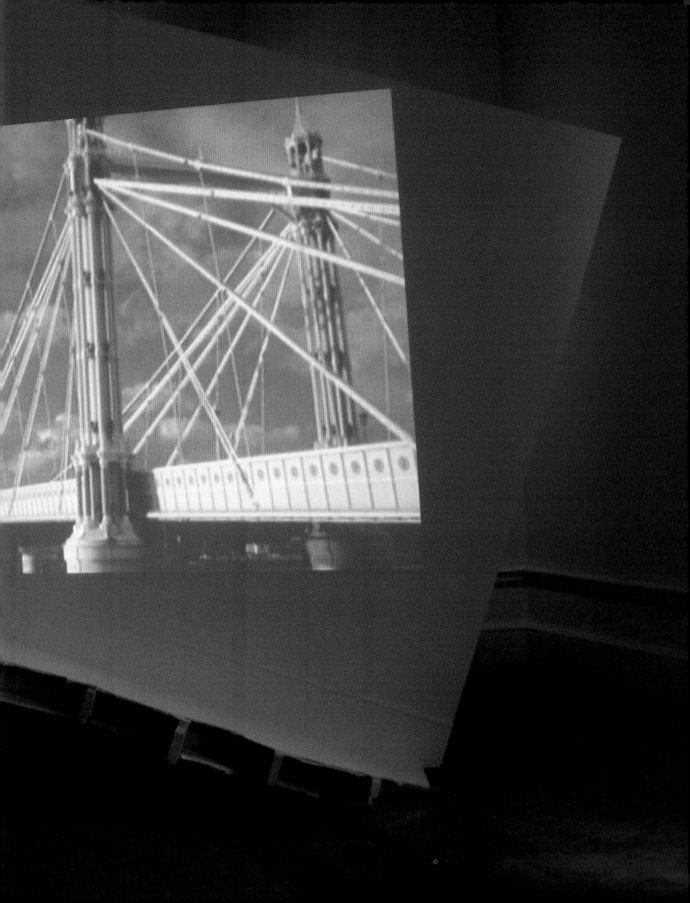

Index

Royal Academy of Arts in London, 2009

Registered charity number 212798

Royal Academy of Arts

Registered charity number 212798

The Royal Academy of Arts has a unique position as an independent institution led by eminent artists and architects whose purpose is to promote the creation, enjoyment and appreciation of the visual arts through exhibitions, education and debate. The Royal Academy receives no annual funding via government, and is entirely reliant on self-generated income and charitable support.

You and/or your company can support the Royal Academy of Arts in a number of different ways:

- Almost £60 million has been raised for capital projects, including the Jill and Arthur M Sackler Wing, the restoration of the Main Galleries, the restoration of the John Madejski Fine Rooms, and the provision of better facilities for the display and enjoyment of the Academy's own collections of important works of art and documents charting the history of British art.
- Donations from individuals, trusts, companies and foundations also help support the Academy's internationally renowned exhibition programme, the conservation of the Collections and education projects for schools, families and people with special needs; as well as providing scholarships and bursaries for postgraduate art students in the Royal Academy Schools.
- As a company, you can invest in the Royal Academy through arts sponsorship, corporate membership and corporate entertaining, with specific opportunities that relate to your budgets and marketing or entertaining objectives.

- A legacy is perhaps the most personal way to make a lasting contribution, through the Trust endowment fund, ensuring that the enjoyment you have derived is guaranteed for future generations.

To find out ways in which individuals can support this work, or a specific aspect of it, please contact Ian Vallance on 020 7300 5624.

To explore ways in which companies, trusts and foundations can become involved in the work of the Academy, please contact Michael Eldred on 020 7300 5979.

To discuss leaving a legacy to the Royal Academy, please contact Reema Khan on 020 7300 5666.

Membership of the Friends

Registered charity number 272926

The Friends of the Royal Academy was founded in 1977 to support and promote the work of the Royal Academy. It is now one of the largest such organisations in the world, with around 90,000 members.

As a Friend you enjoy free entry to every RA exhibition and much more...

- Visit exhibitions as often as you like, bypassing ticket queues
- Bring a family adult guest and up to four family children, all free
- See exhibitions first at previews

- Keep up to date with *RA Magazine*
- Have access to the Friends Room

Why not join today?

- At the Friends desk in the Front Hall
- Online at www.royalacademy.org.uk/friends
- Ring 020 7300 5664 any day of the week

Support the foremost UK organisation for promoting the visual arts and architecture, which receives no regular government funding. *Please also ask about Gift Aid.*

Summer Exhibition Organisers

Alice Bygraves
Chris Cook
Edith Devaney
Lorna Dryden
Laura Egan
Kay Harwood
Paul Sirr

Royal Academy Publications

Lucy Bennett
David Breuer
Carola Krueger
Sophie Oliver
Peter Sawbridge
Nick Tite

Book design: 01.02
Photography: John Bodkin
Colour reproduction: DawkinsColour
Printed in Italy by Graphicom

ISBN 978-1-905711-43-7

Illustrations

Page 2: Prof Bryan Kneale RA, *Triton III* (detail). Stainless steel, H 480 cm

Page 4: Prof John Hoyland RA, *Lost in Blue* (detail). Acrylic, 236 × 254 cm

Page 7: Joc, Jon & Josch, *Inbetween* (detail)

Pages 8–9: Prof Bryan Kneale RA, *Triton III*

Page 17: Antoni Tàpies Hon RA, *Aixeta/Tap* (detail)

Pages 20–1: Installation in Gallery I. Foreground: Allen Jones RA, *Enchanteresse*. Bronze, H 196 cm. Background: Anselm Kiefer Hon RA, *Tryptique*. Mixed media, 190 × 330 cm

Page 27: William Tucker RA, *Greek Horse*. Bronze, H 220 cm

Page 37: Lucy Farley, *Hampstead Heath Summer* (detail)

Page 67: Diana Armfield RA, *Flowers in June in the Moustier Jug* (detail)

Pages 72–3: Installation in the Small Weston Room

Page 79: Prof Phillip King CBE PPRA, *Blue Swell*. Foam, PVC and steel, H 193 cm

Page 101: Installation in Gallery IV. Foreground: Prof Bryan Kneale RA, *Gemini*. Polished stainless steel, H 50cm; Marcus Harvey, *Gloria Mundis*. Bronze, H 104 cm

Page 115: Danny Rolph, *Gladstone* (detail). Mixed media, 140 × 200 cm

Page 123: Installation in Gallery VI. Foreground: Phillipa Downs, Sarah Milburn, Julio Alves and Louise Fricker, *Elizabethan Dress*. Mixed media, H 165 cm. Back wall: Trine Olrik, *Sliding*. Cardboard, 160 × 120 cm

Page 137: Clyde Hopkins, *Bucolic Hippy Painting 2* (detail)

Page 147: Sir Anthony Caro OM CBE RA, *Erl King* (detail)

Page 153: Barton Hargreaves, *Paradise Lost* (detail)

Page 161: Prof Michael Sandle RA, *Iraq: The Sound of Your Silence*. Limewood, H 200 cm

Pages 174–5: Installation in the Lecture Room. Foreground: John Maine RA, *Conversation with Distant Stones*. Mixed media, H 145 cm

Page 179: Barry Flanagan OBE RA, *Moon Gold Hare*. Bronze and gilded bronze, H 163 cm

Page 185: Vicky Hawkins, *Ethal and the Mutant Babies* (detail). Film still

Photographic Acknowledgements

Page 11: © Damien Hirst, photo Prudence Cuming Associates

Page 12: courtesy of the artists

Page 17: © the artist, care of Waddington Galleries

Pages 20–1 (background): courtesy of the artist and Jay Jopling/ White Cube, London

Page 23: private collection, courtesy of Peter Freeman, Inc., New York

Page 24: © the artist, care of Waddington Galleries

Pages 82–3: the Eli and Edythe L. Broad Collection, Los Angeles

Page 101 (foreground): courtesy of the artist and Jay Jopling / White Cube, London

Page 128 (top): © Rogers Stirk Harbour + Partners

Page 130 (bottom): Andrew Putler

Page 134 (bottom): Richard Bryant